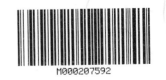
MICROSCOPIC ART FORMS FROM THE PLANT WORLD

R. ANHEISSER

Dover Publications, Inc.
Mineola, New York

The CD-ROM in this book contains all of the images. There is no installation necessary. Just insert the CD into your computer and call the images into your favorite software (refer to the documentation with your software for further instructions). The pages, as shown in the book, have been saved as high-resolution JPEG files. Each individual image has been saved as both a high-resolution and an Internet-ready JPEG file, and as a TIFF file.

The "Images" folder on the CD contains four different folders. All of the high-resolution JPEG files have been placed one folder, as have all of the Internet-ready JPEG files, all of the high-resolution full-page JPEG files, and TIFF files. The images in the two JPEG folders and the TIFF folder are identical. Every image has a unique file name in the following format: xxx.JPG. The first 3 digits of the file name, before the period, correspond to the number printed under the image in the book. The last 3 letters of the file name "JPG," refer to the file format. So, 001.JPG would be the first file in the JPEG folder.

Also included on the CD-ROM is Dover Design Manager, a simple graphics editing program for Windows that will allow you to view, print, crop, and rotate the images.

For technical support, contact:
 Telephone: 1 (617) 249-0245
 Fax: 1 (617) 249-0245
 Email: dover@artimaging.com
 Internet: **http://www.dovertechsupport.com**
 The fastest way to receive technical support is via email or the Internet.

NOTE

This collection of over 450 black-and-white line drawings is from an early-twentieth century portfolio that explores the microscopic details of algae, grasses, herbs, and a variety of other plant forms. German artist Roland Anheisser (1877–1949) loved nature and combined his passion for flora with his illustrative talents to create this excellent guide for students and botanists. The accompanying CD-ROM features high-resolution JPEG files of each page, exactly as shown in the book, and high- and low-resolution JPEG files and TIFF files of each individual motif. We have included on each plate the source of the microscopic images for easy reference.

Bibliographical Note

This Dover edition, first published in 2009, contains all of the illustrations from *Mikroskopische Kunstformen des Pflanzenreiches,* originally published by Gerhard Kühtmann, Dresden, in 1904.

DOVER *Pictorial Archive* SERIES

International Standard Book Number
ISBN-13: 978-0-486-46013-0
ISBN-10: 0-486-46013-4

Manufactured in the United States of America
Dover Publications, Inc., 31 East 2nd Street, Mineola, N.Y. 11501

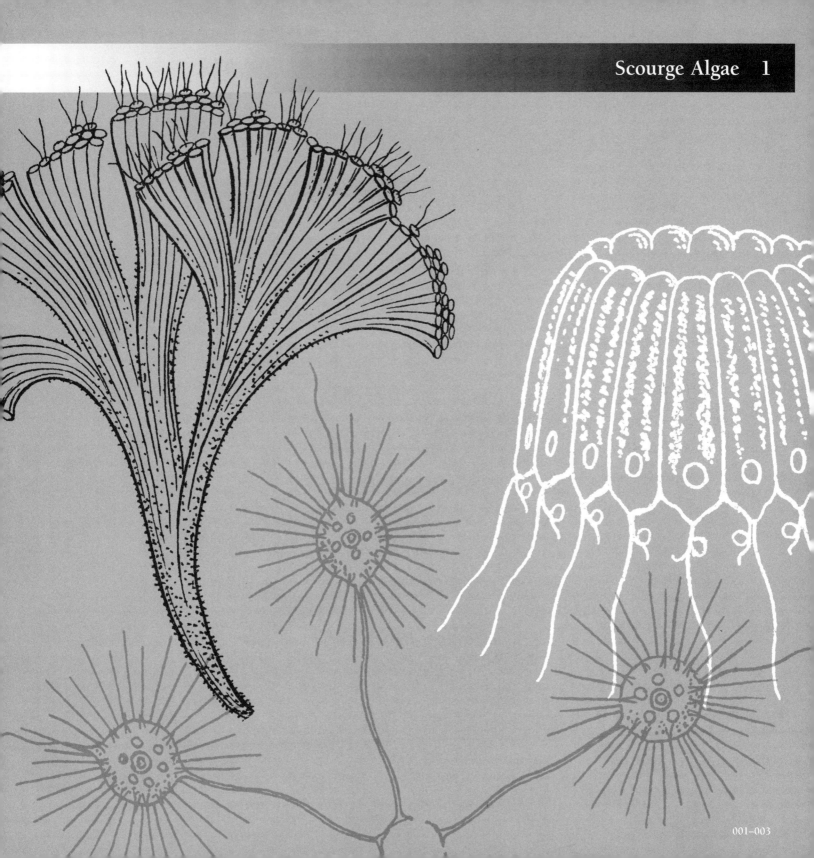

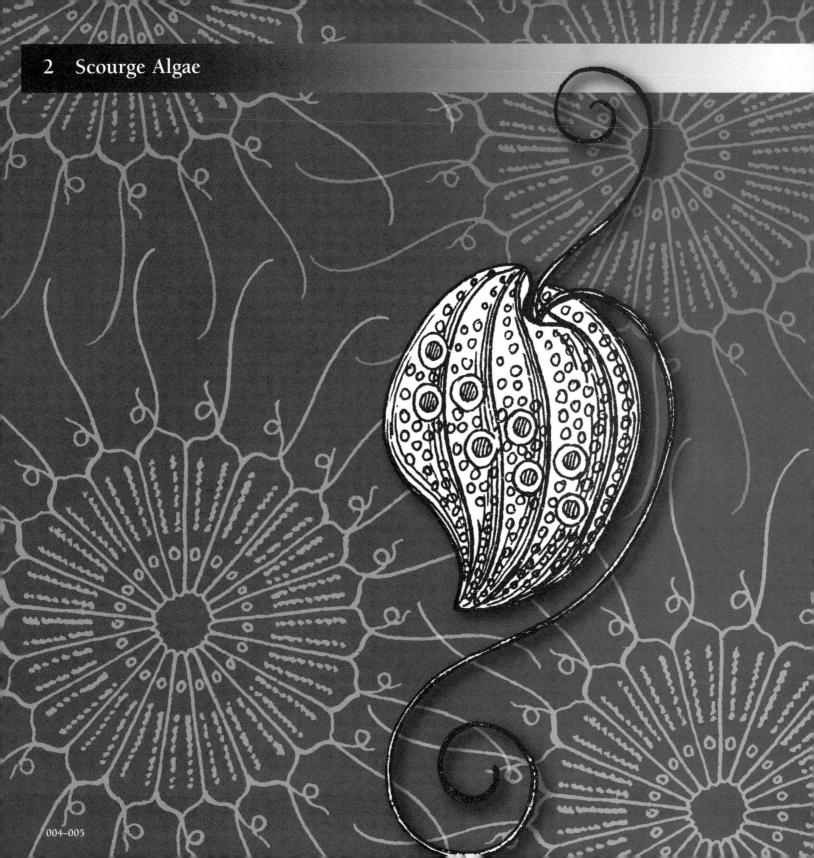

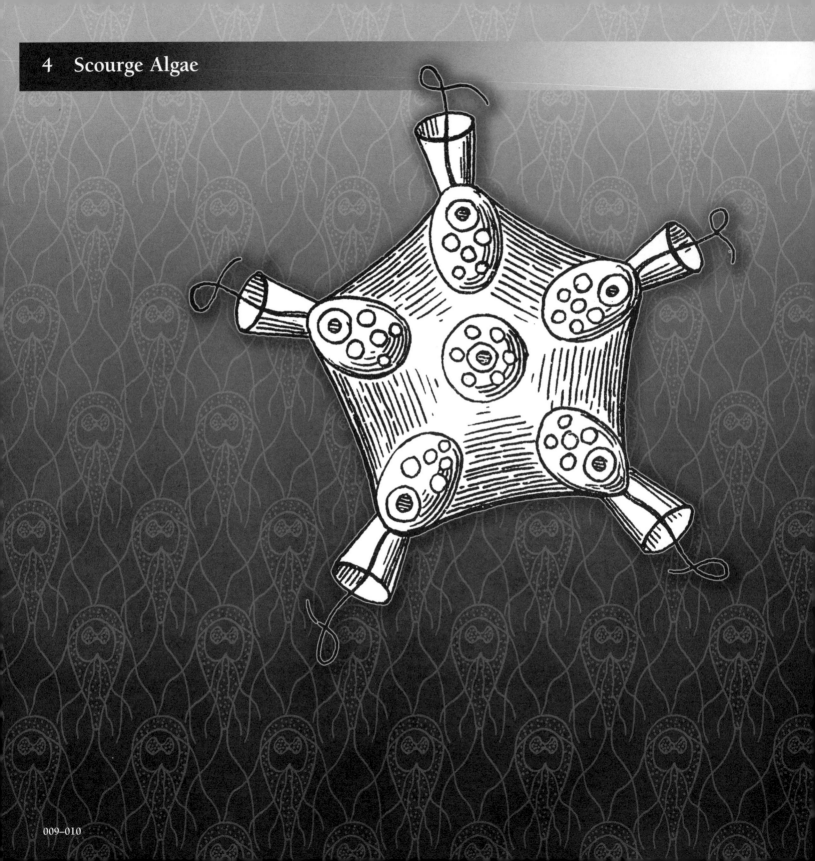

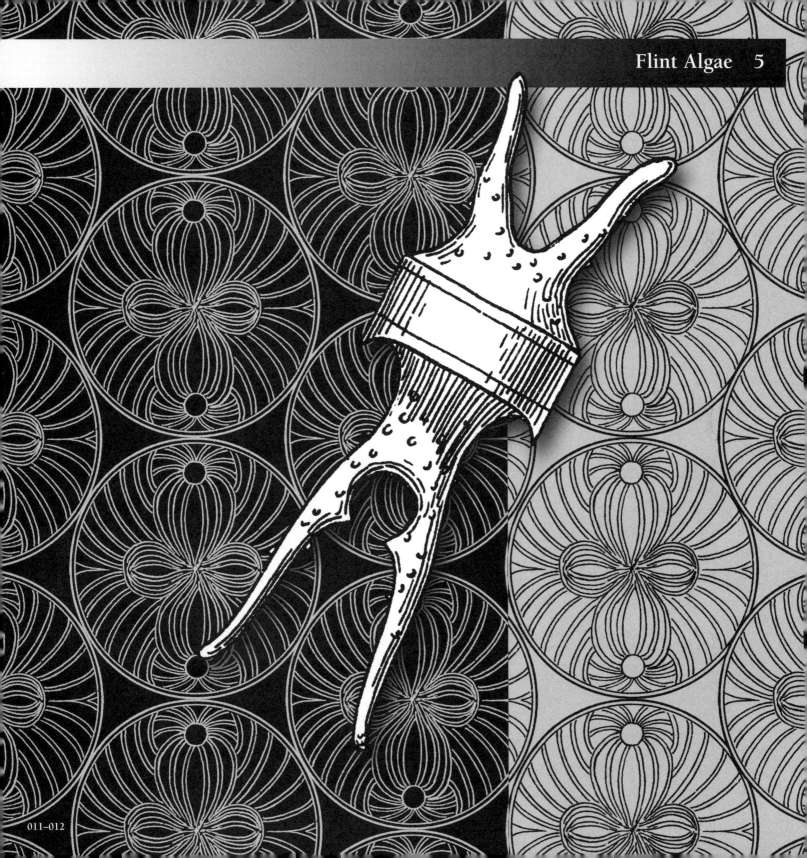

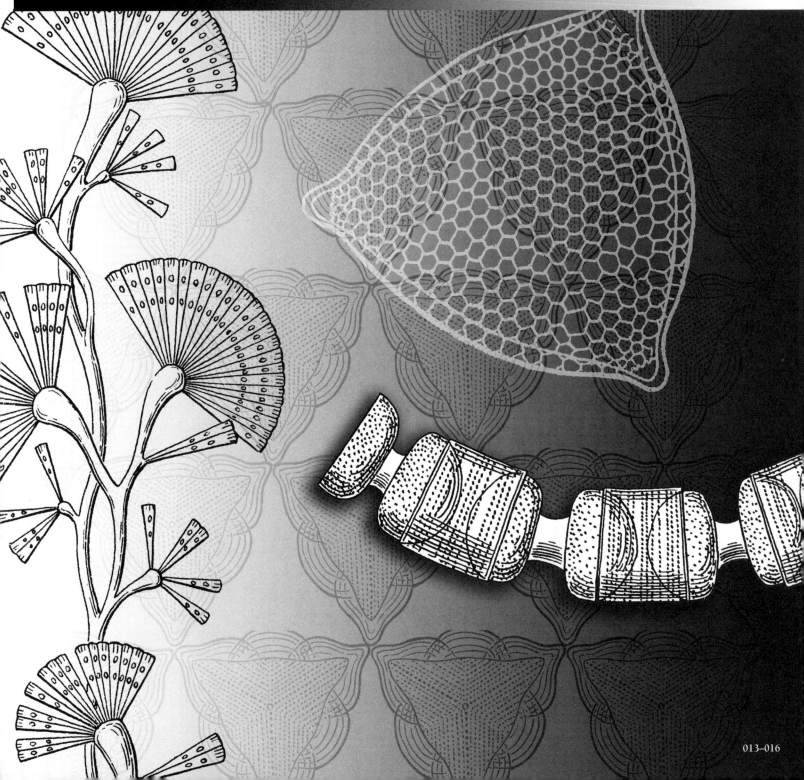

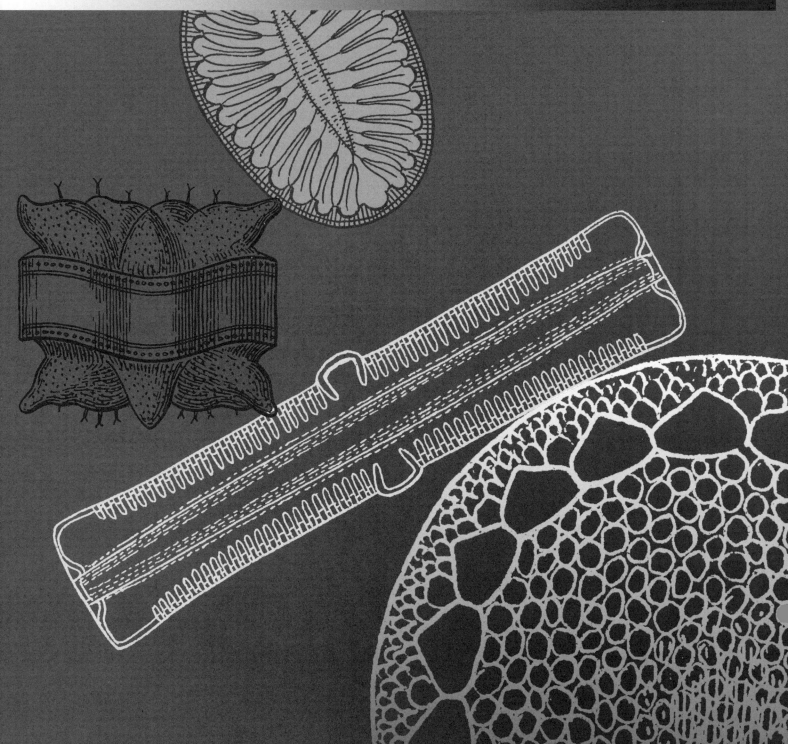

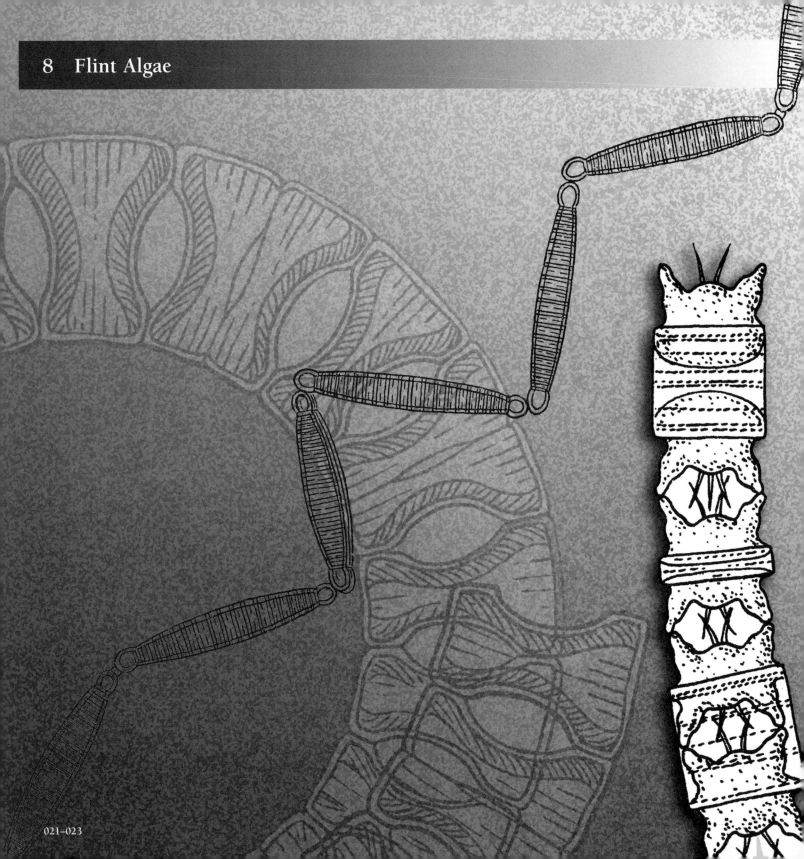

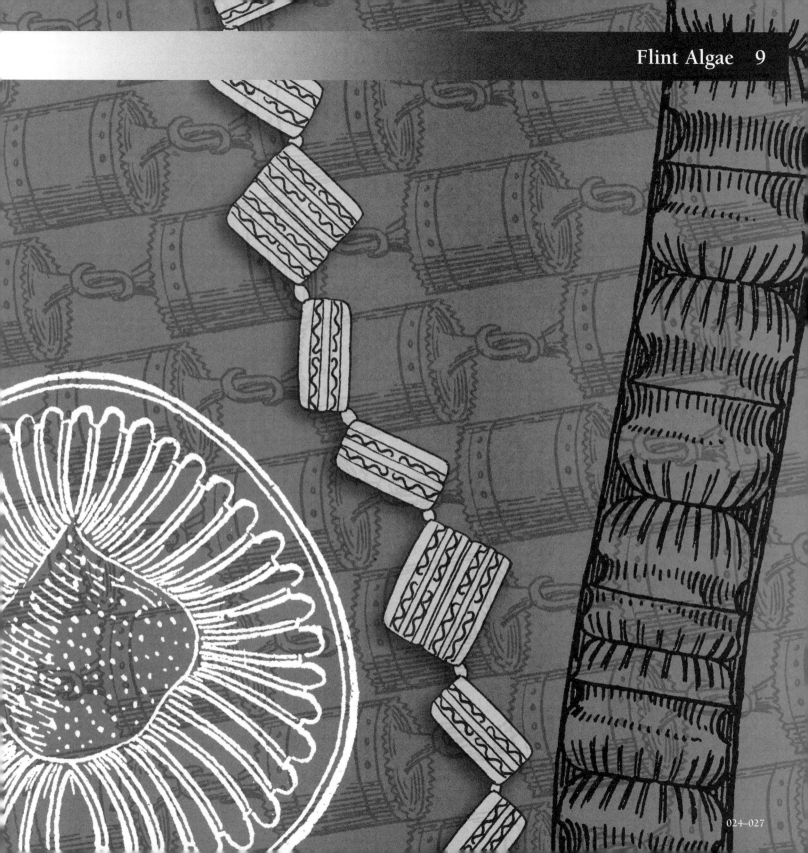

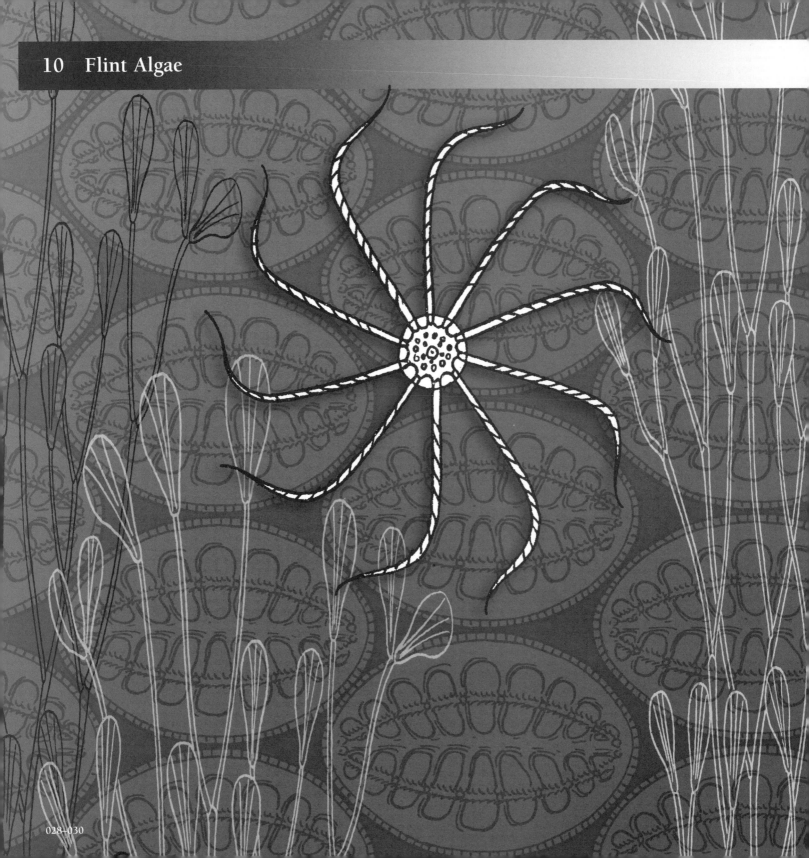

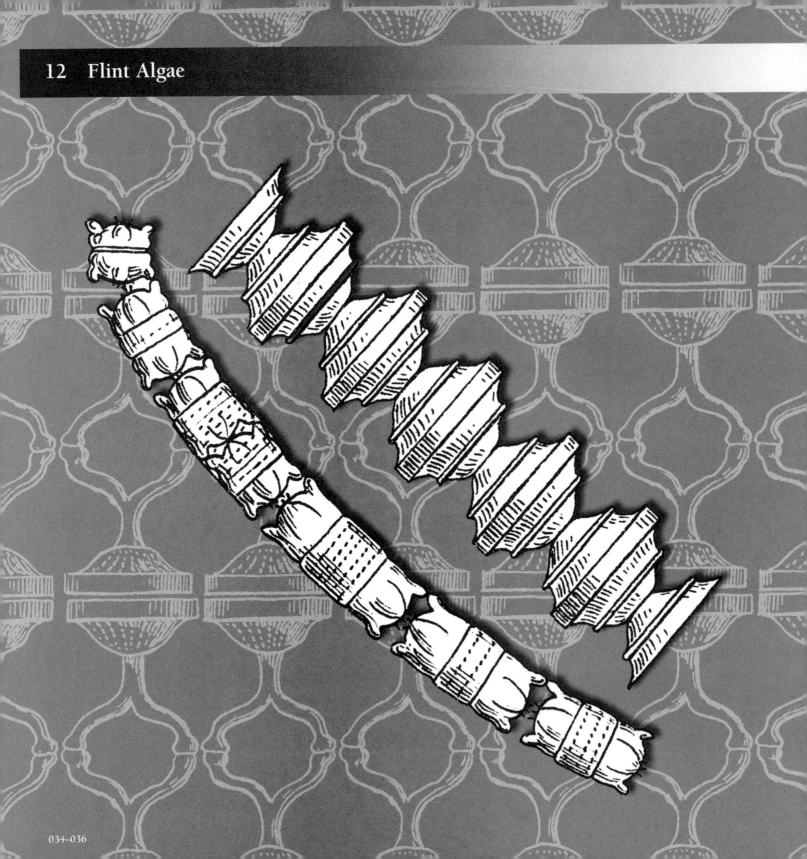

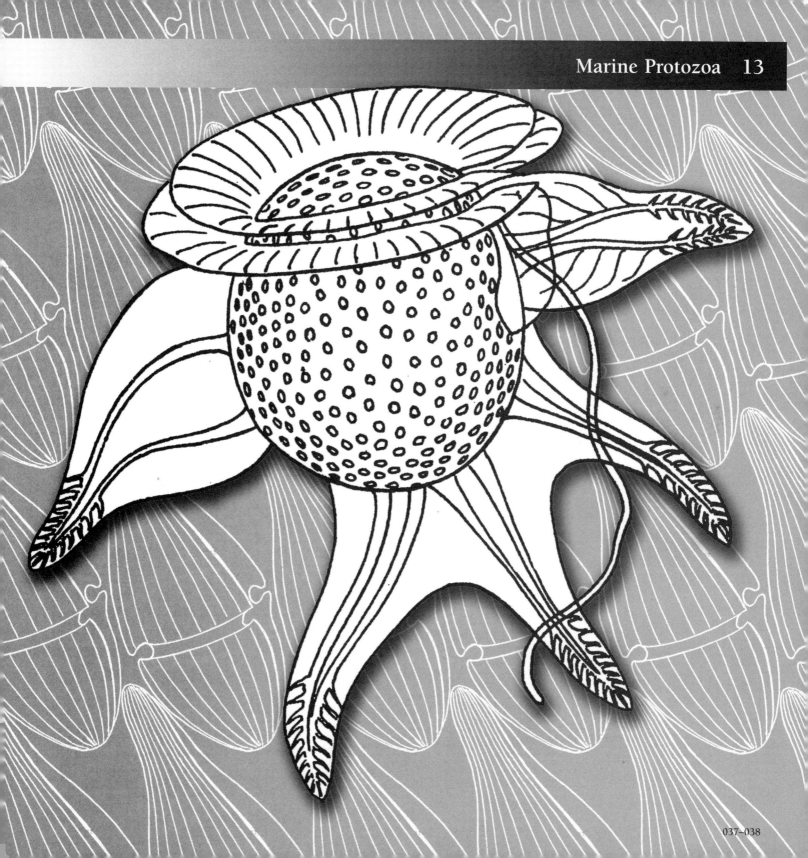

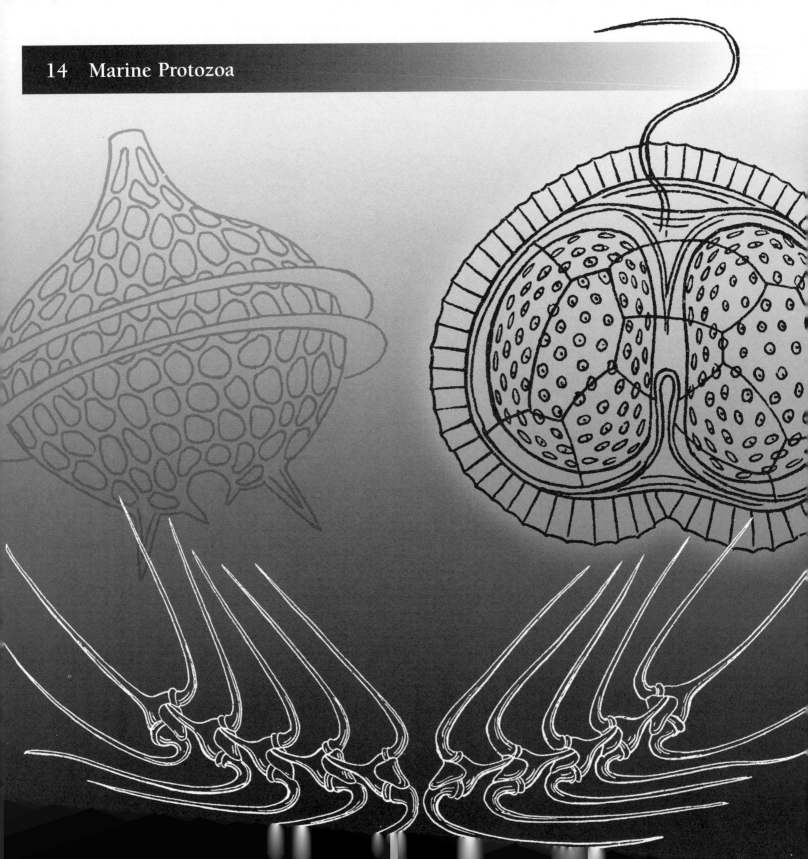

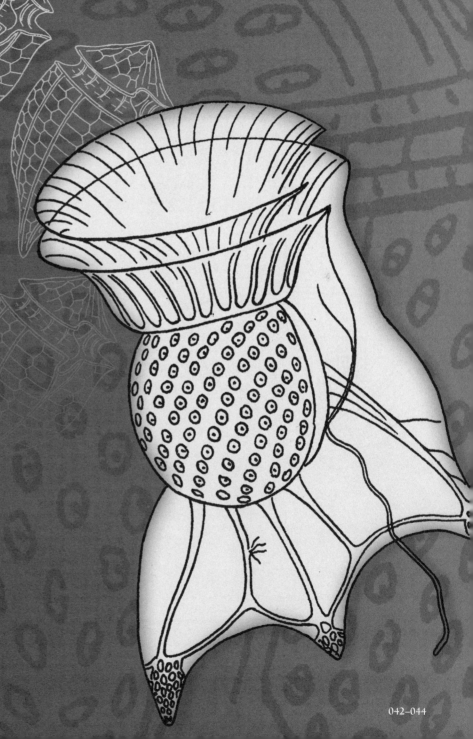

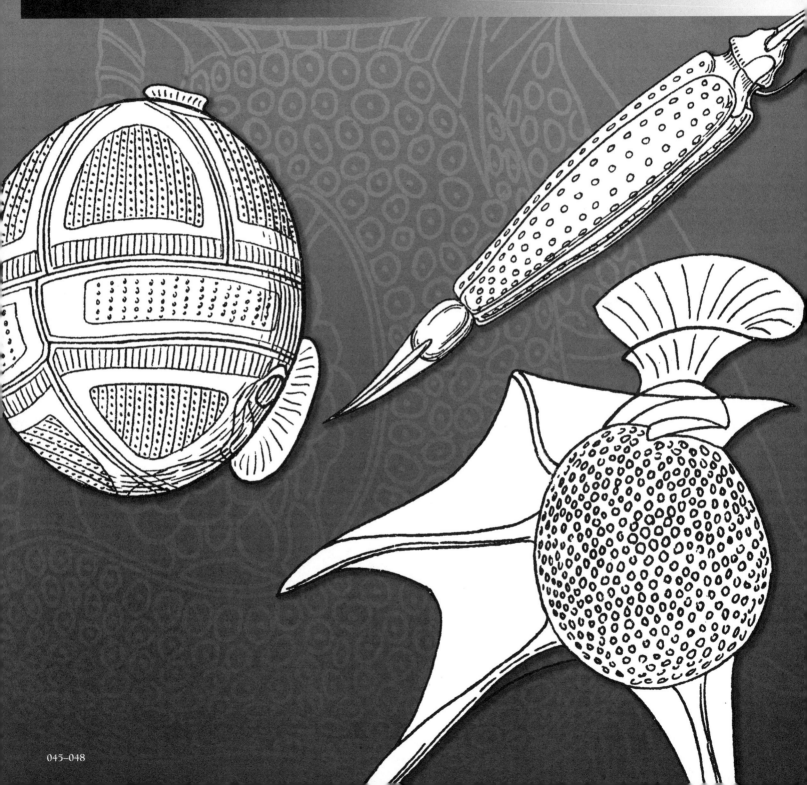

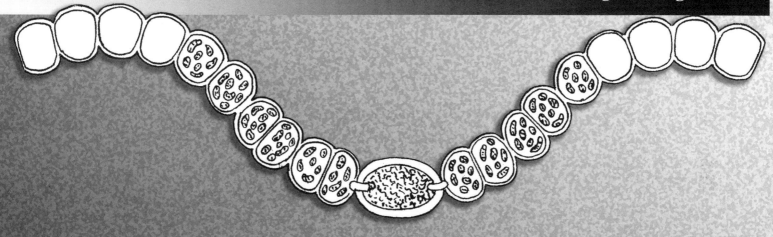

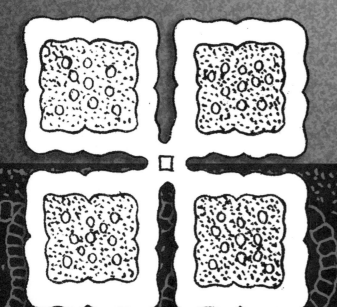

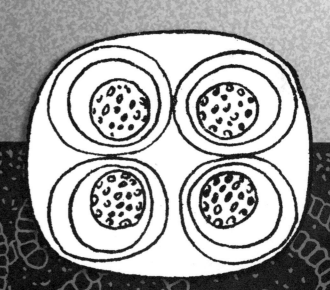

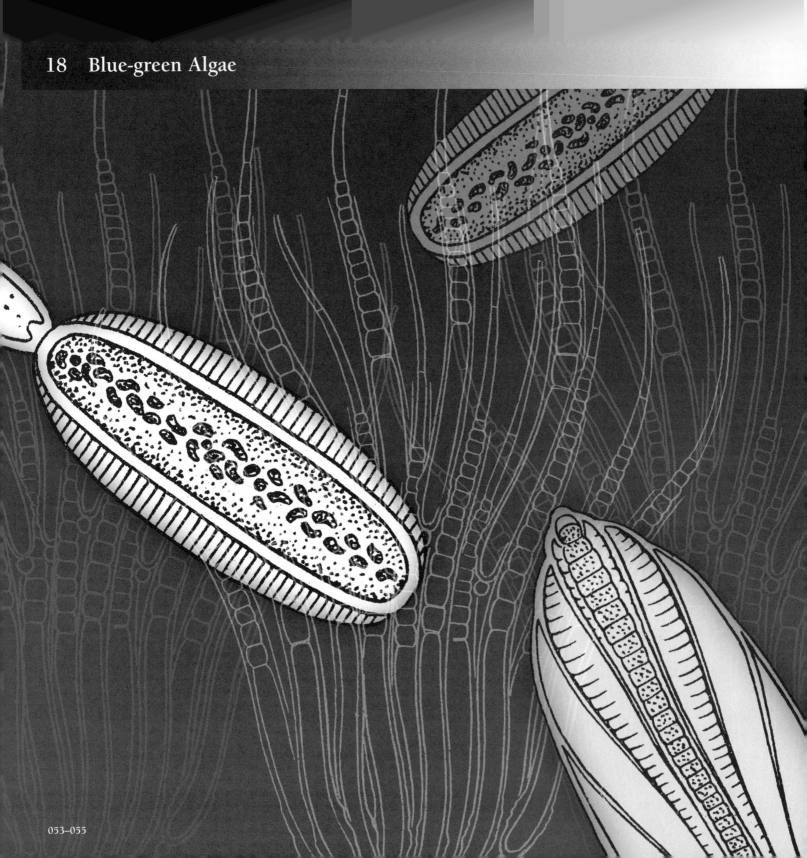

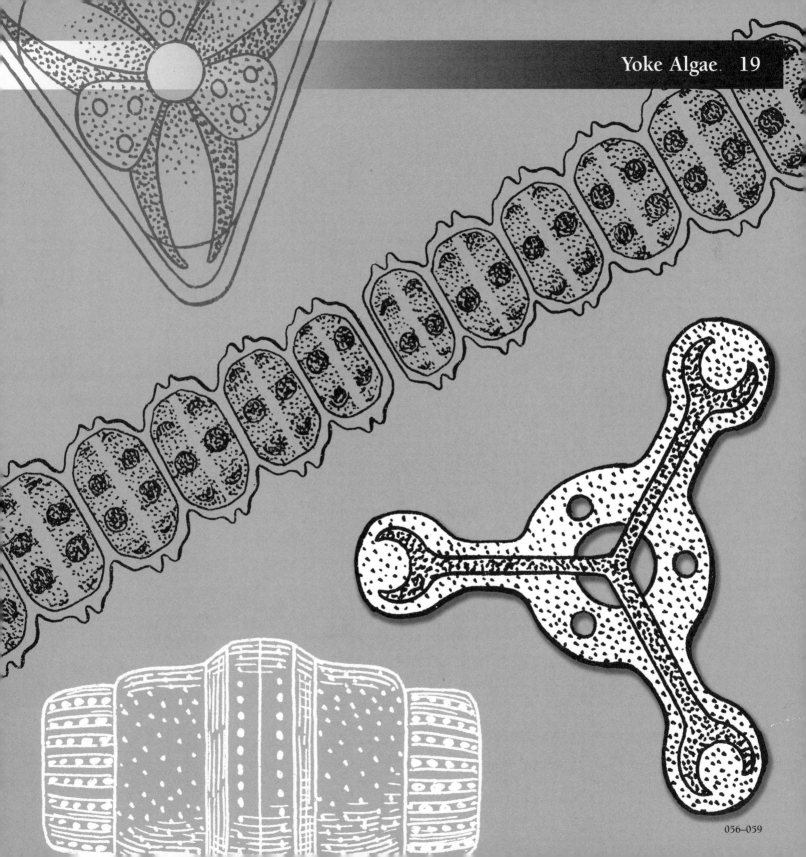

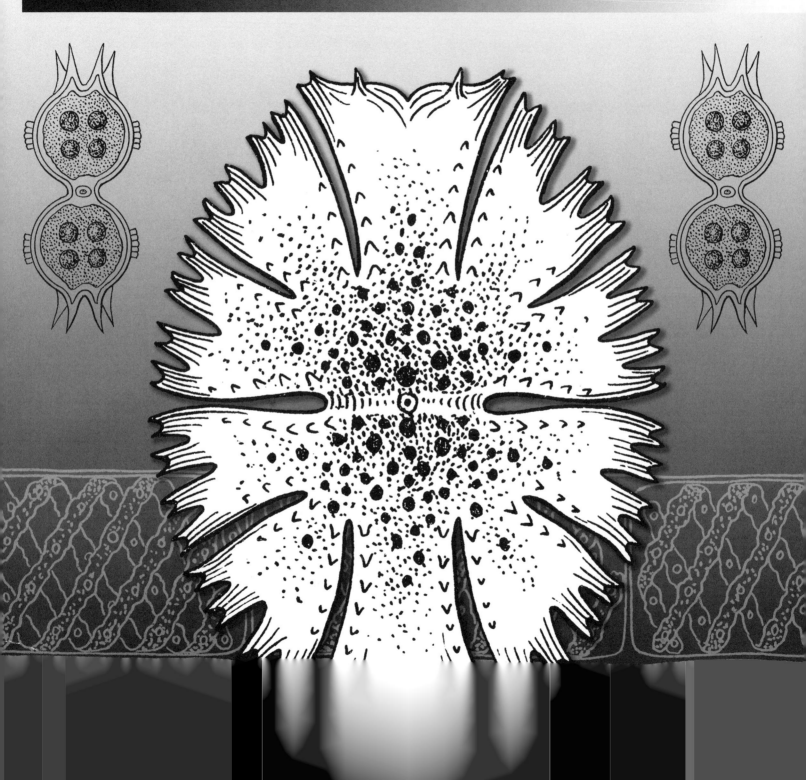

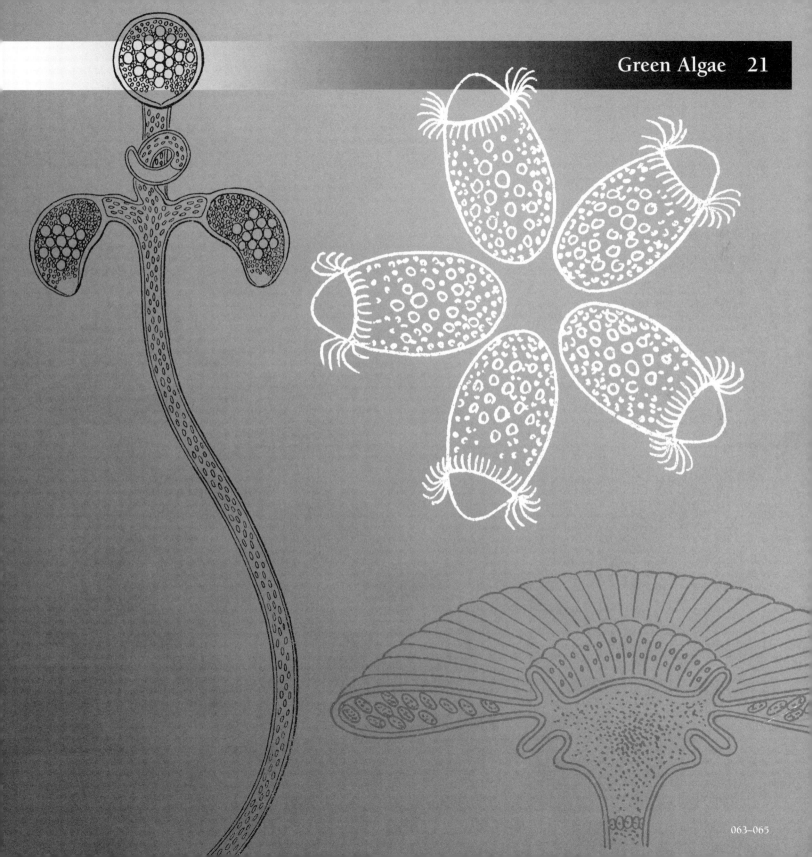

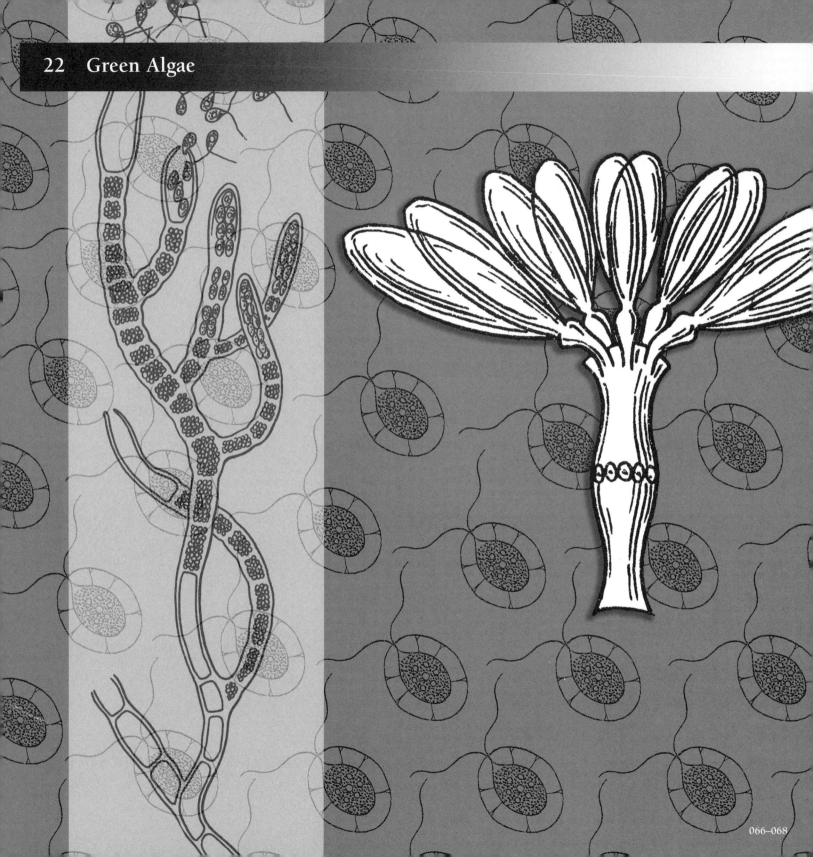

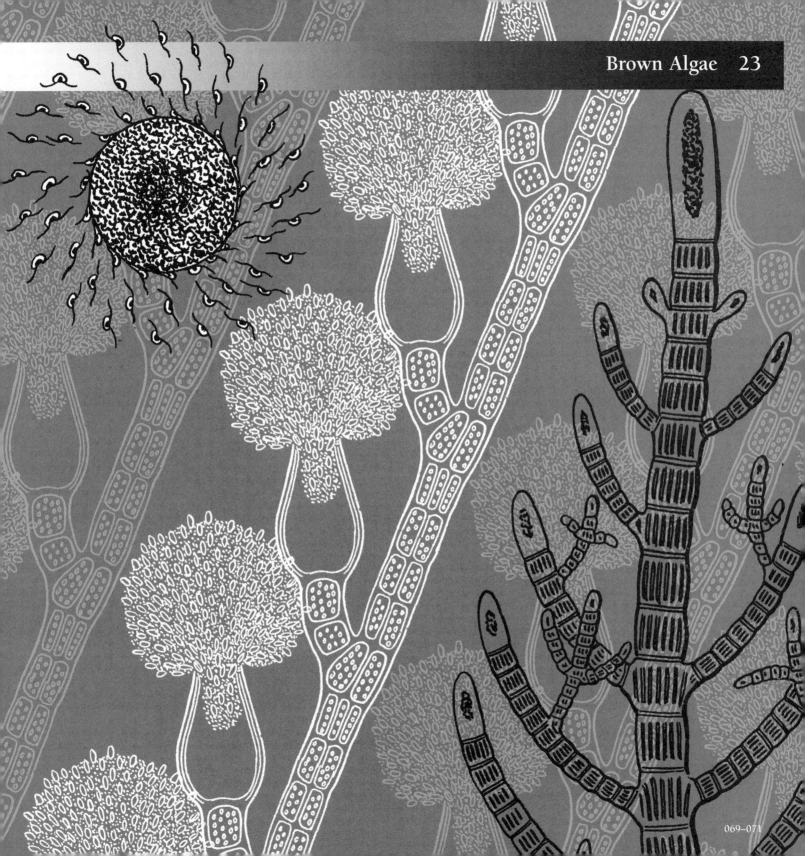

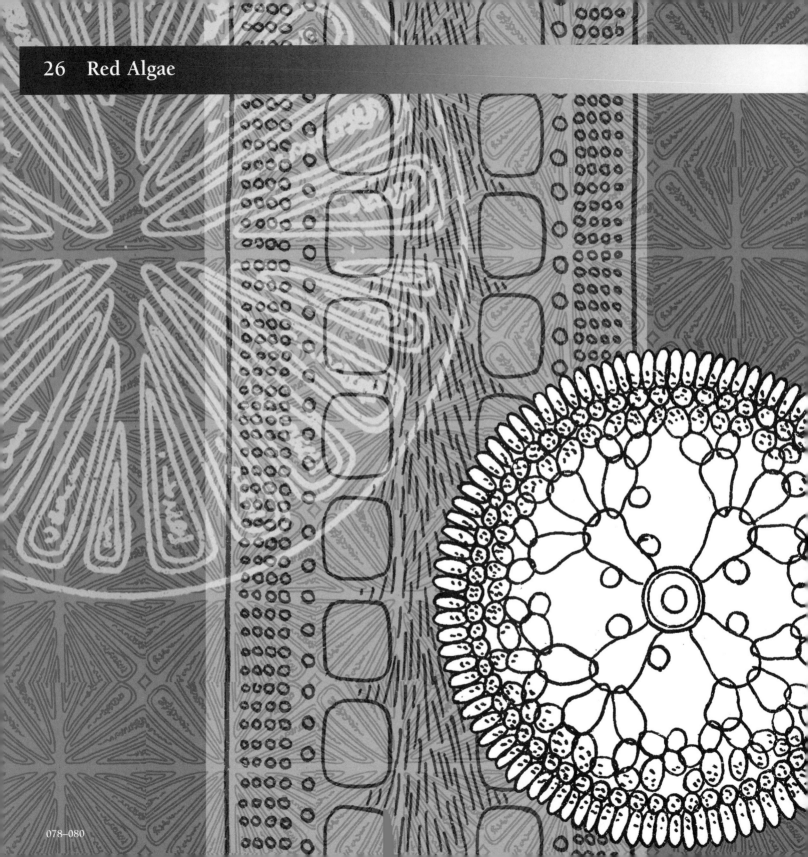

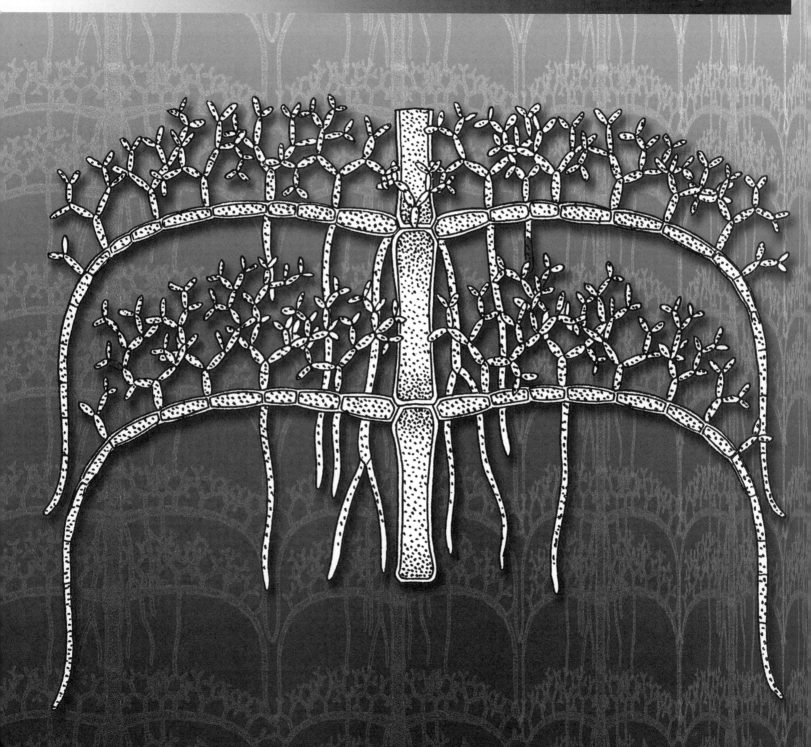

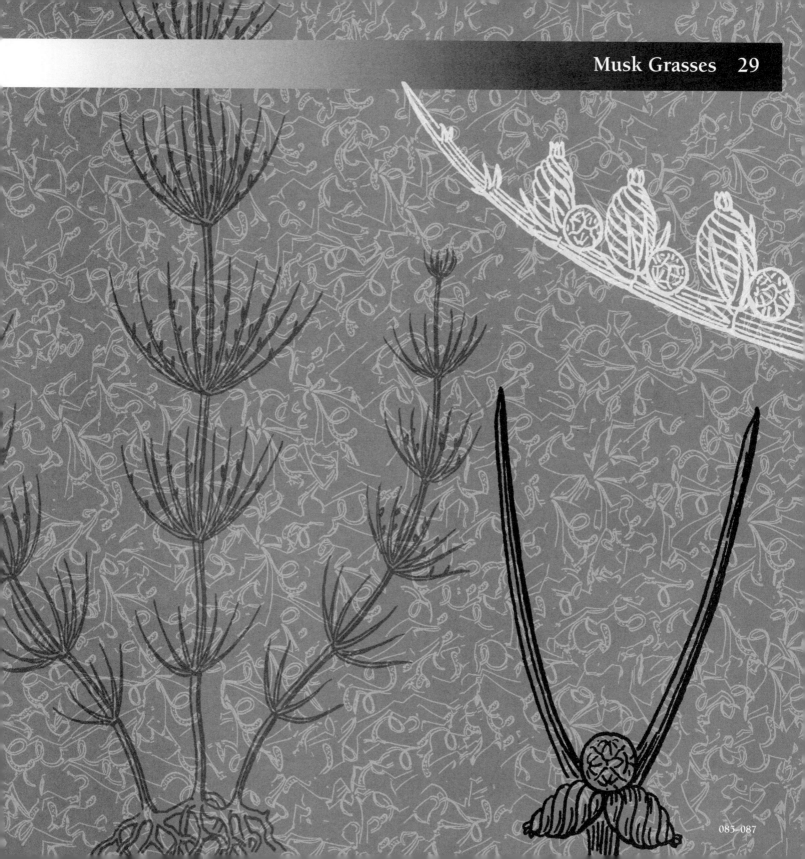

085–087

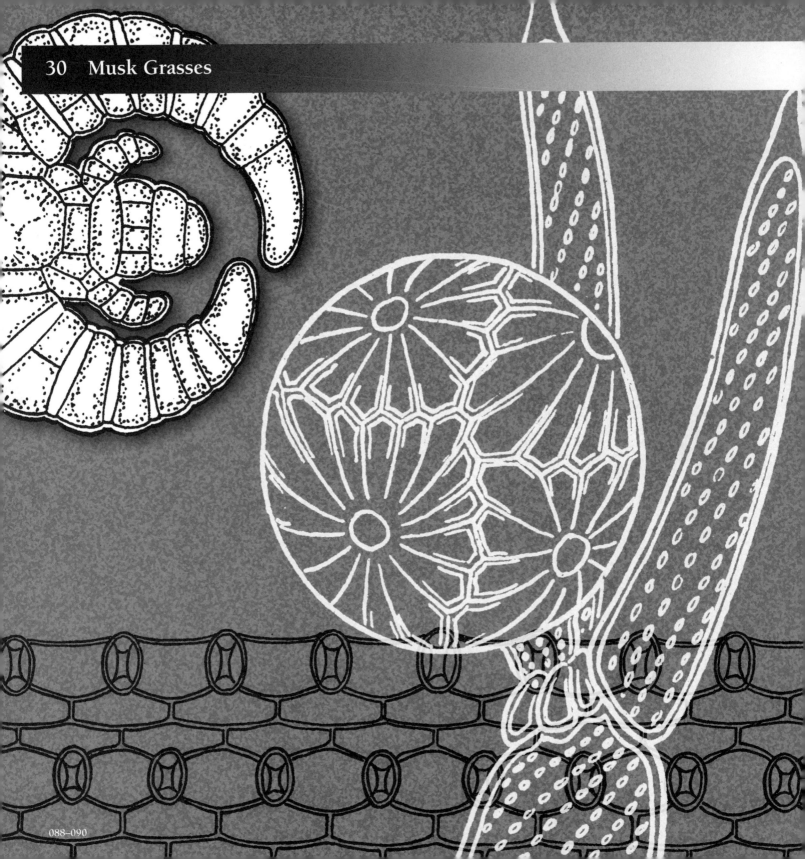

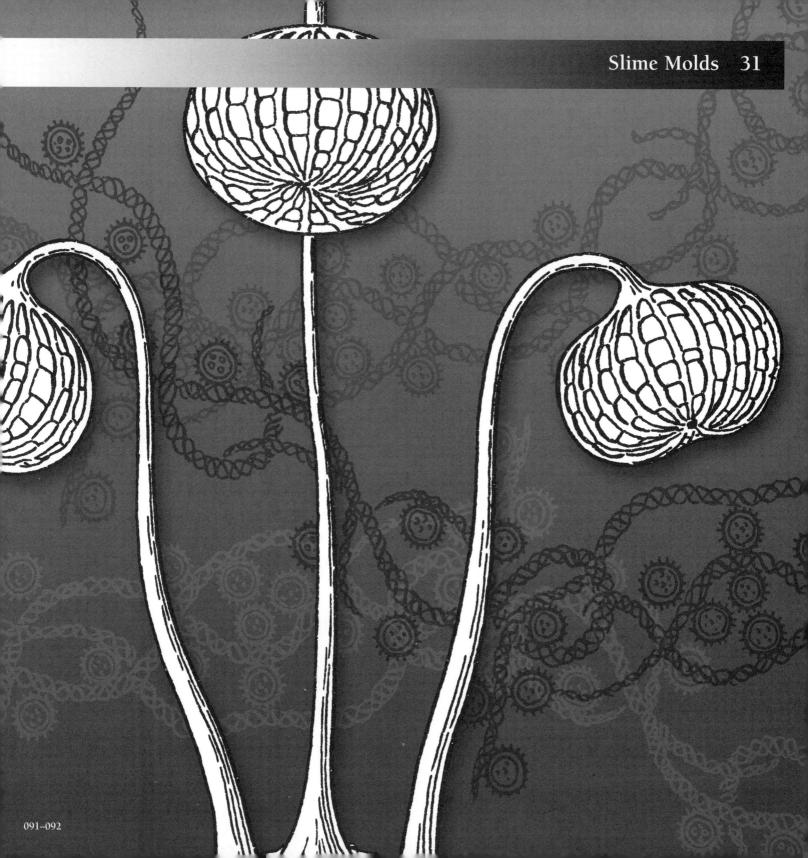

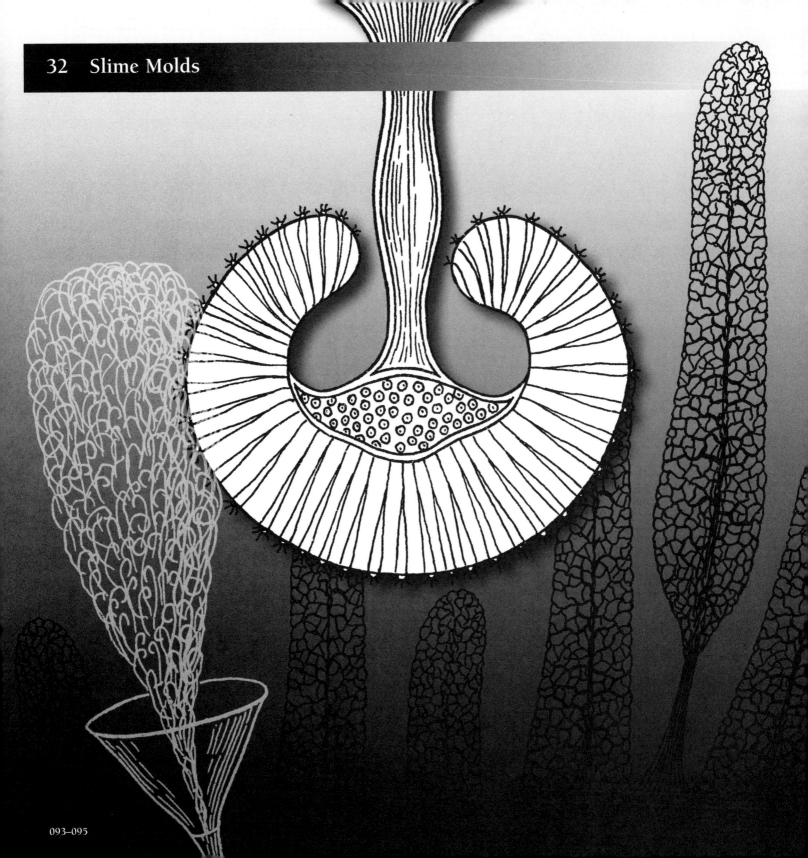

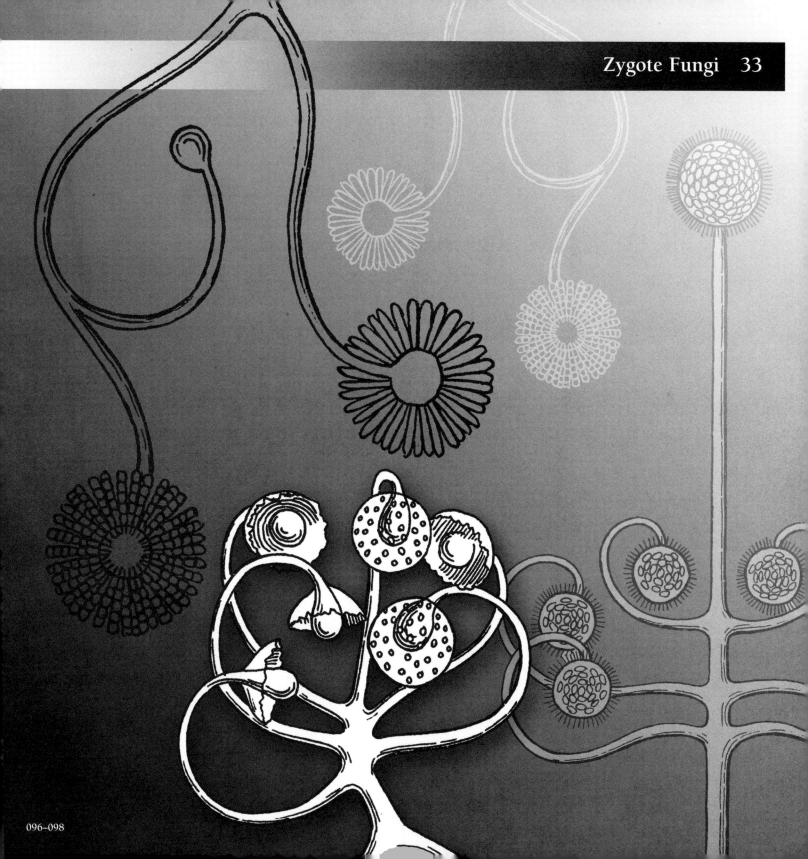

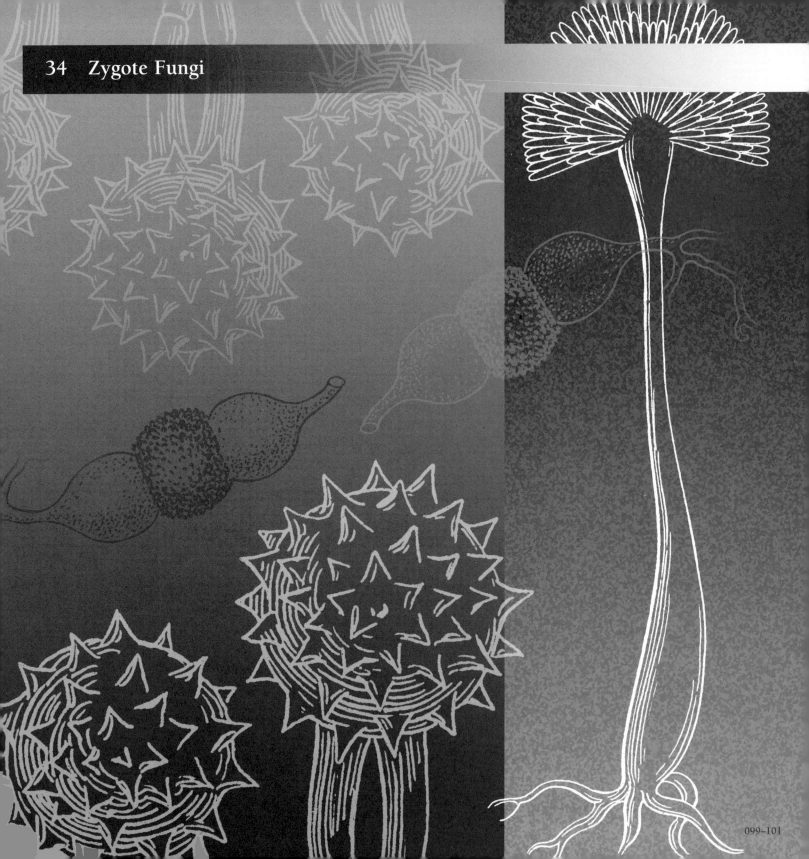

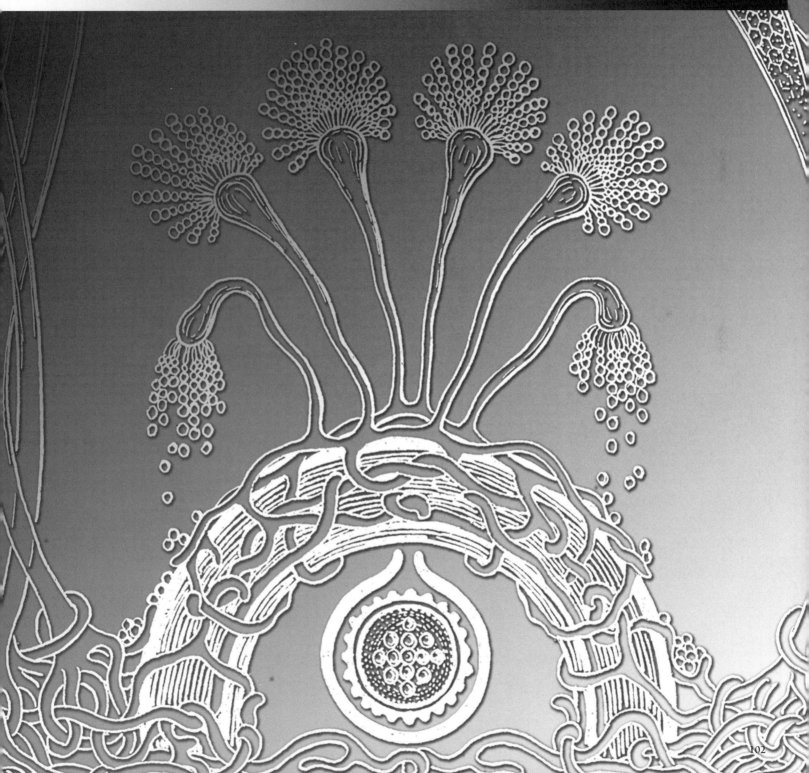

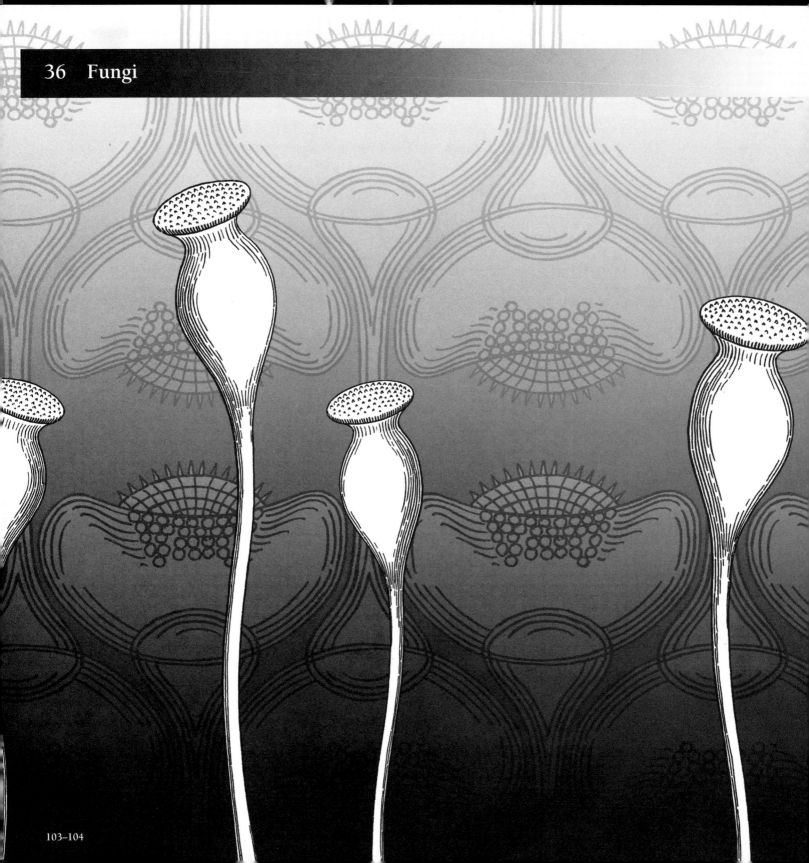

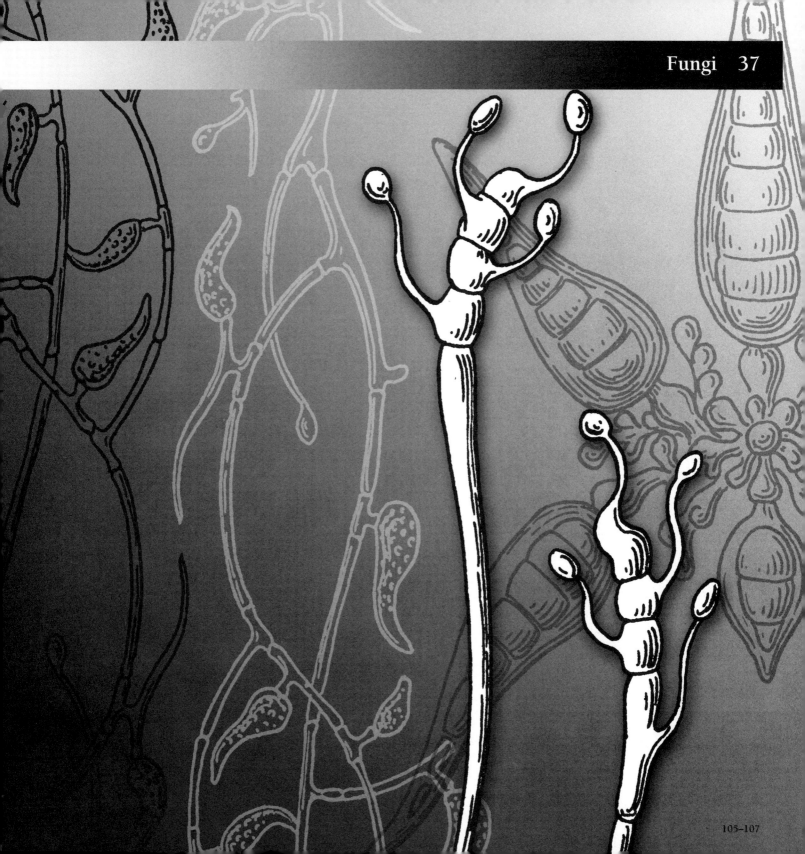

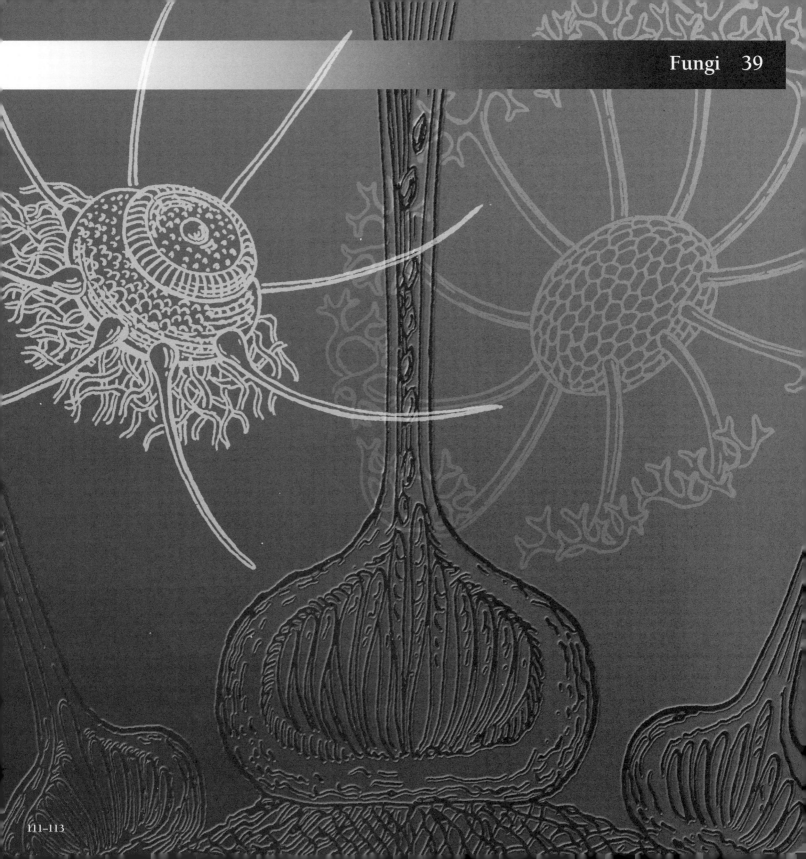

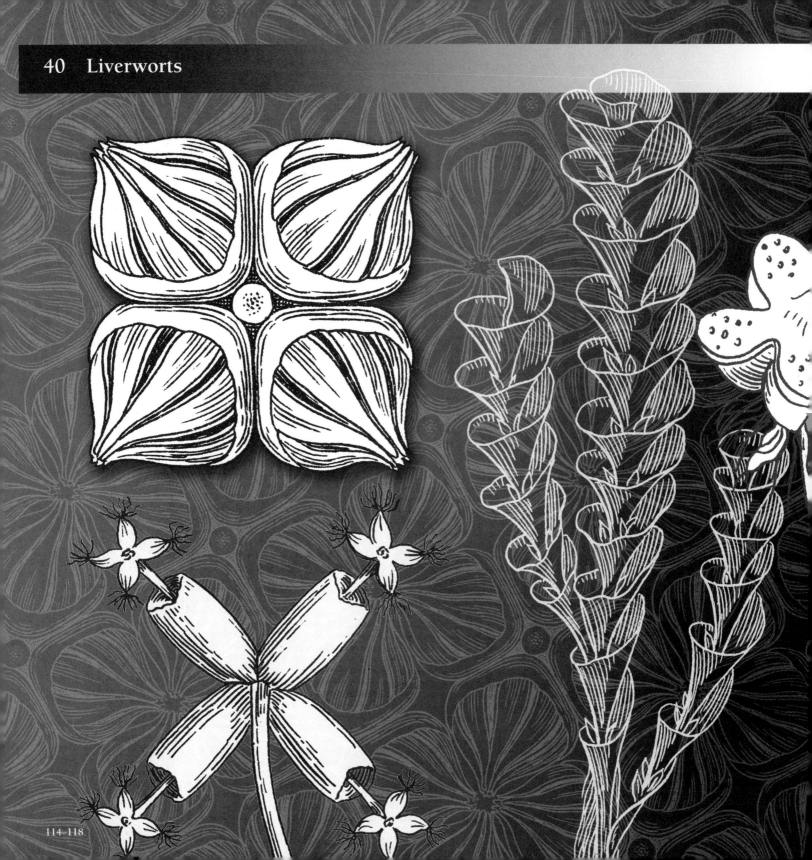

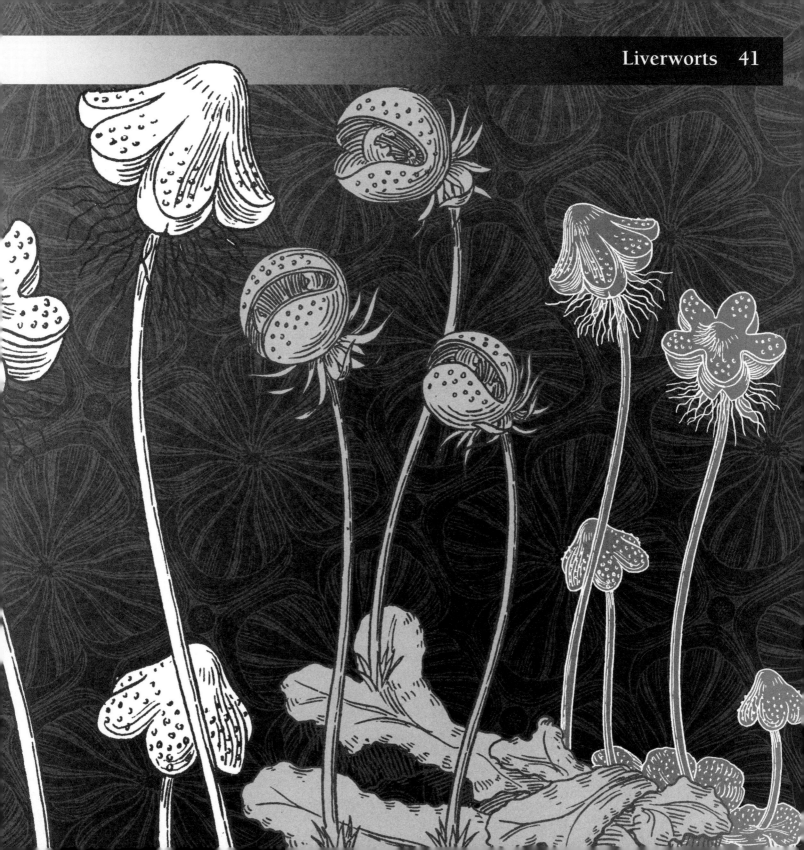

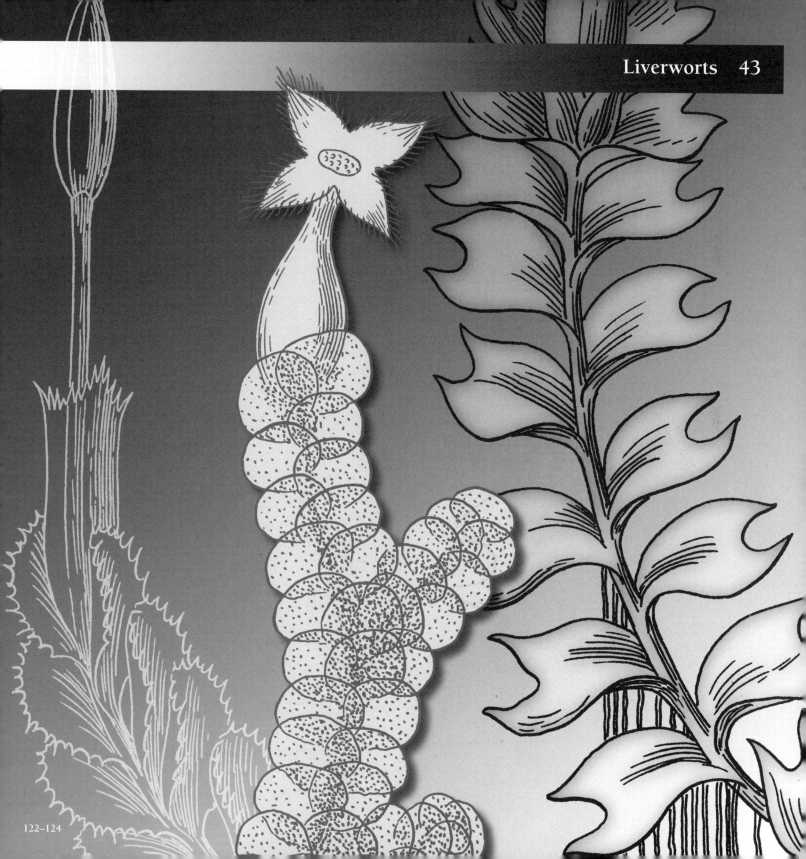

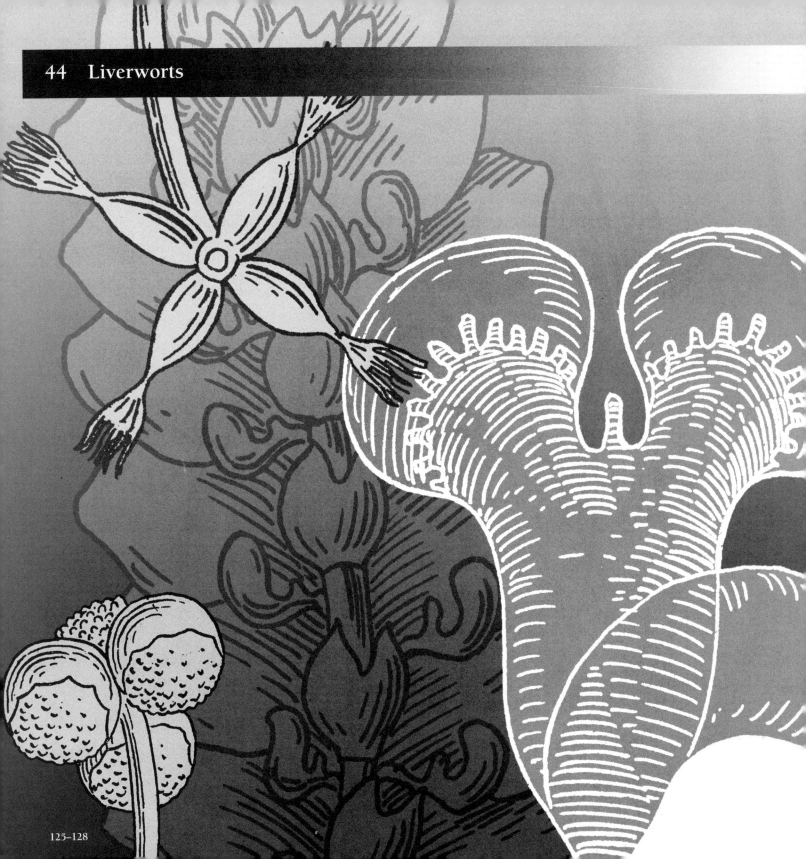

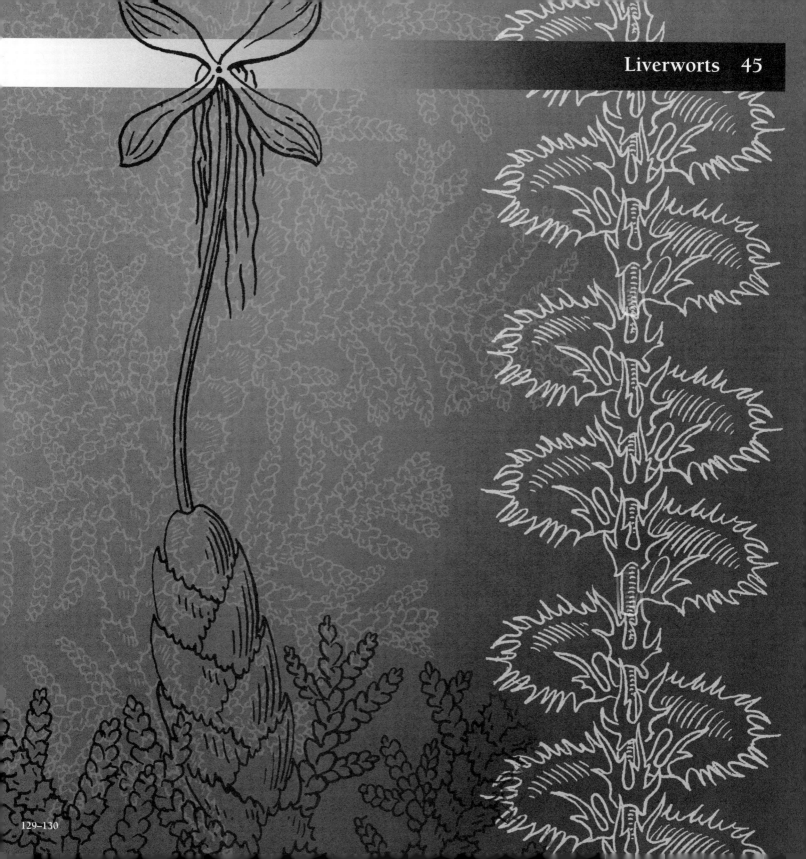

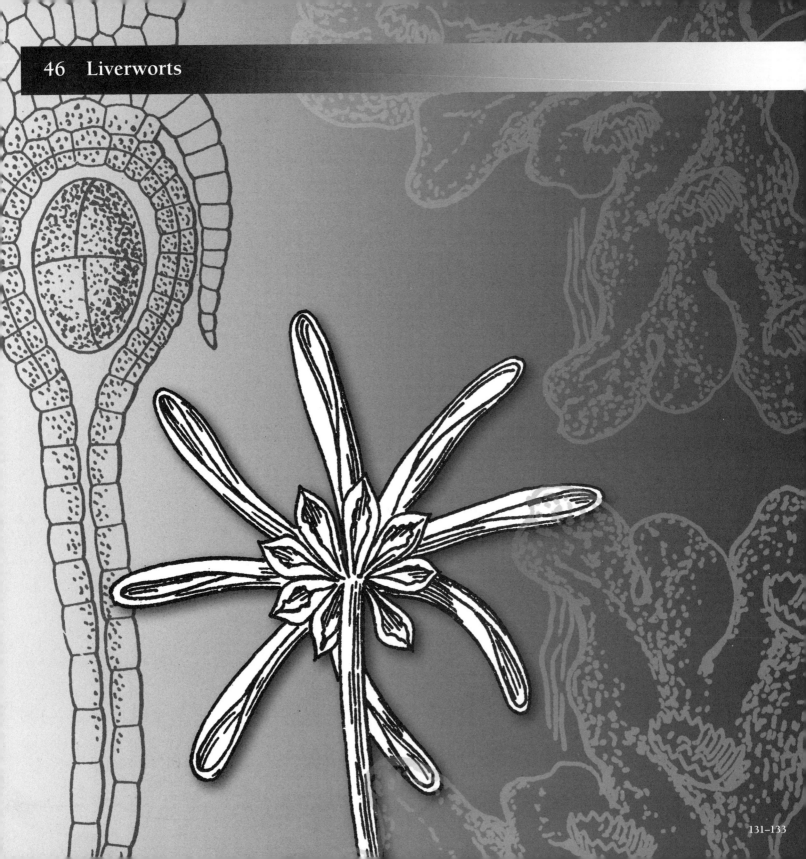

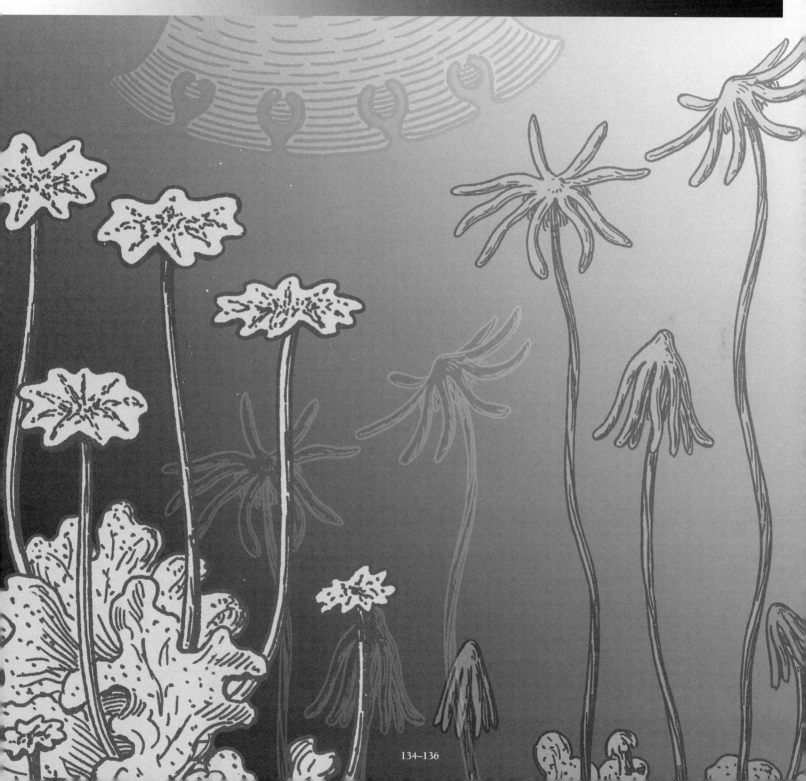

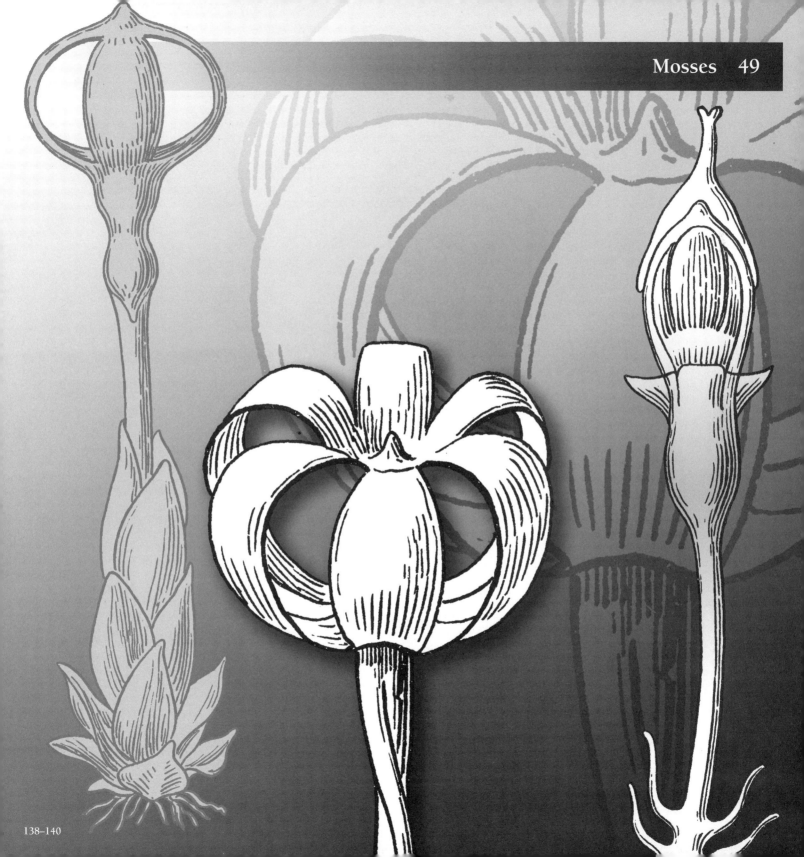

138–140

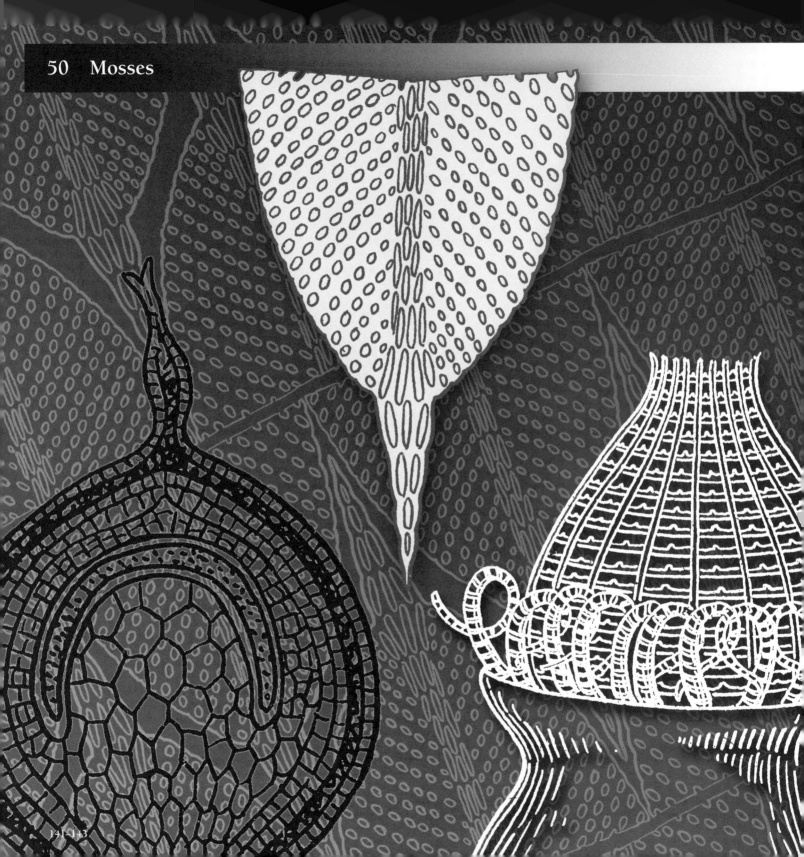

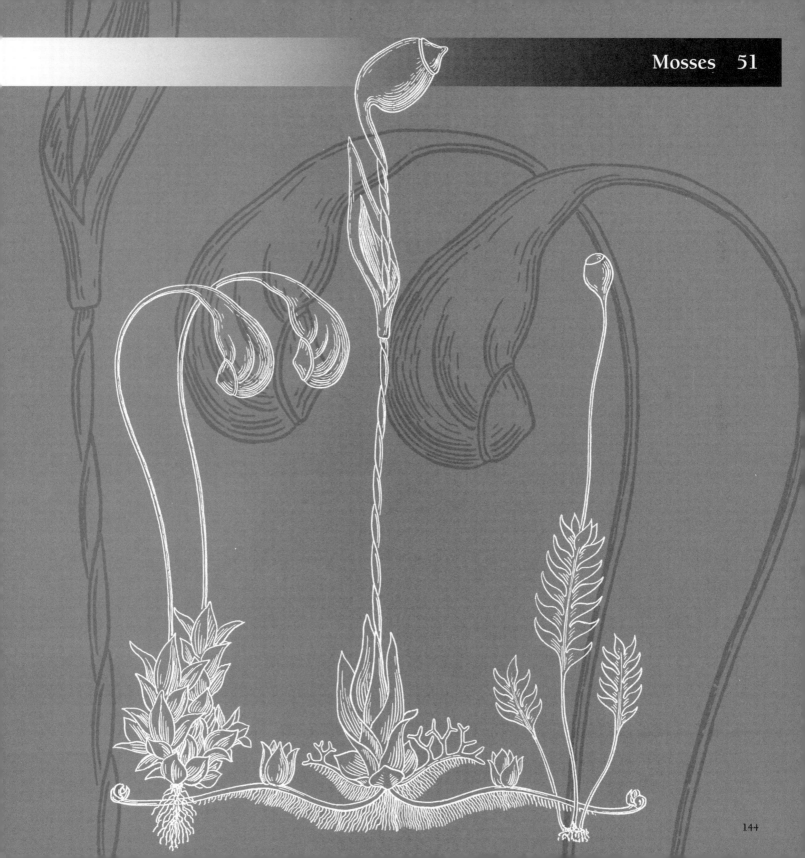

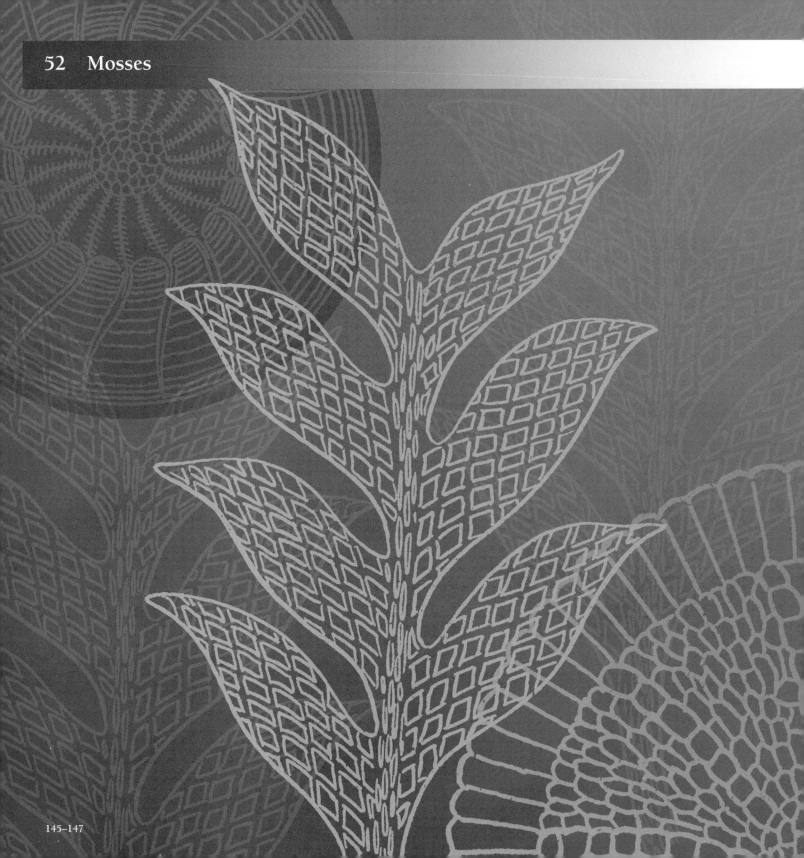

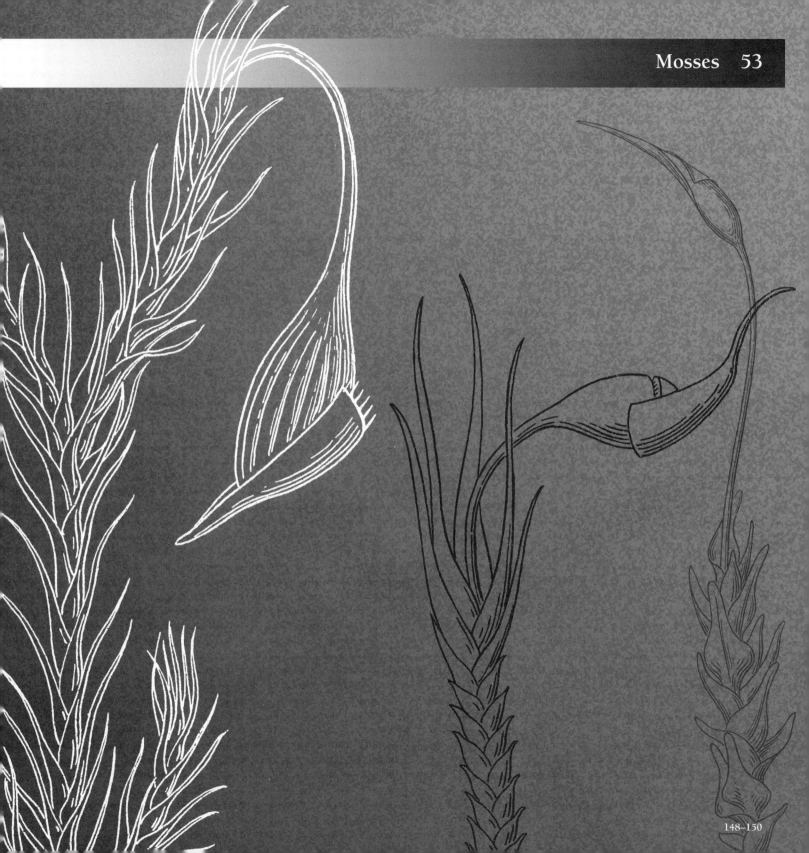

148–150

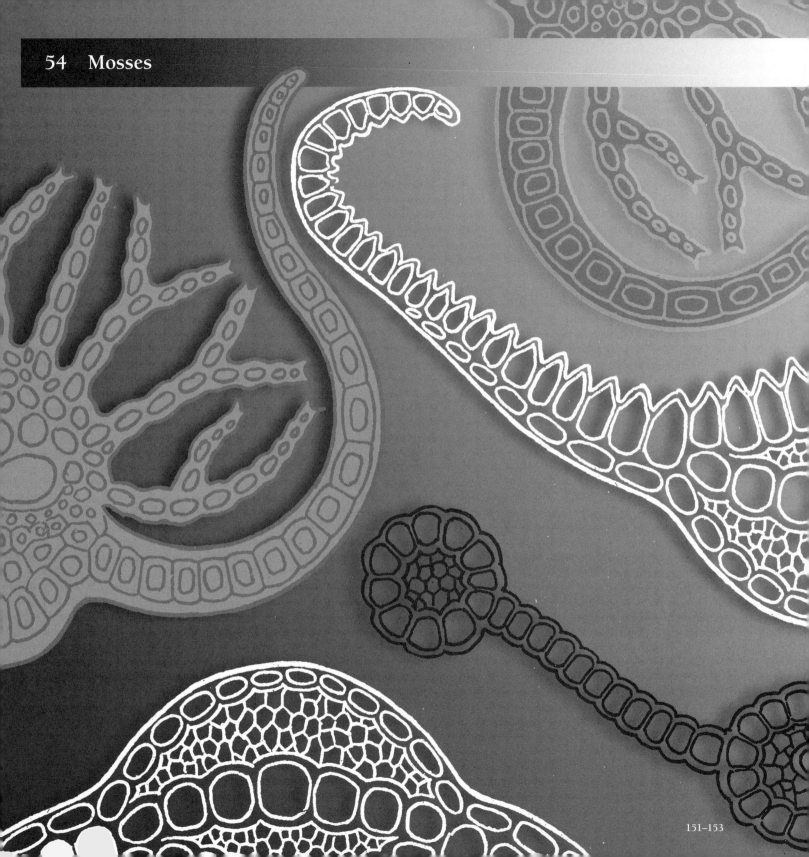

151–153

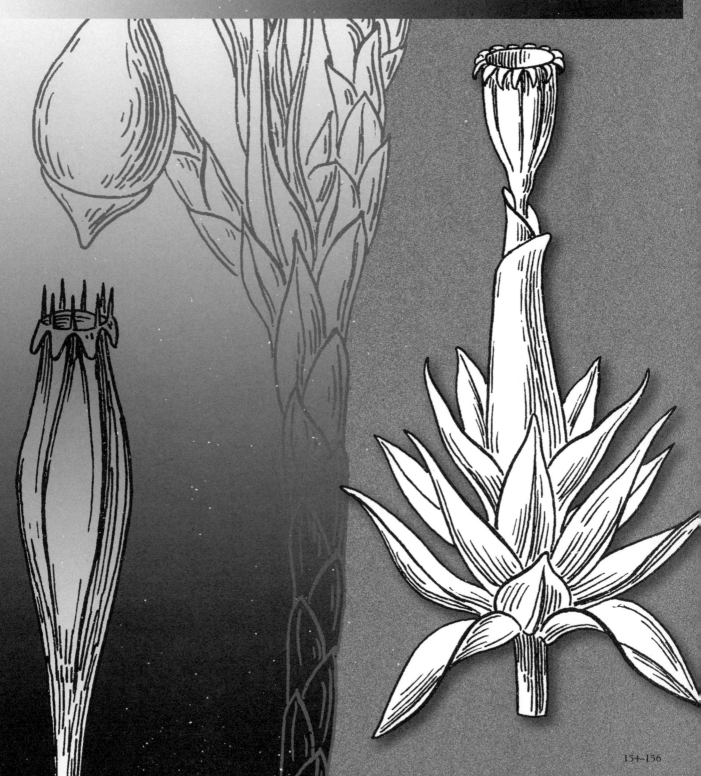

154–156

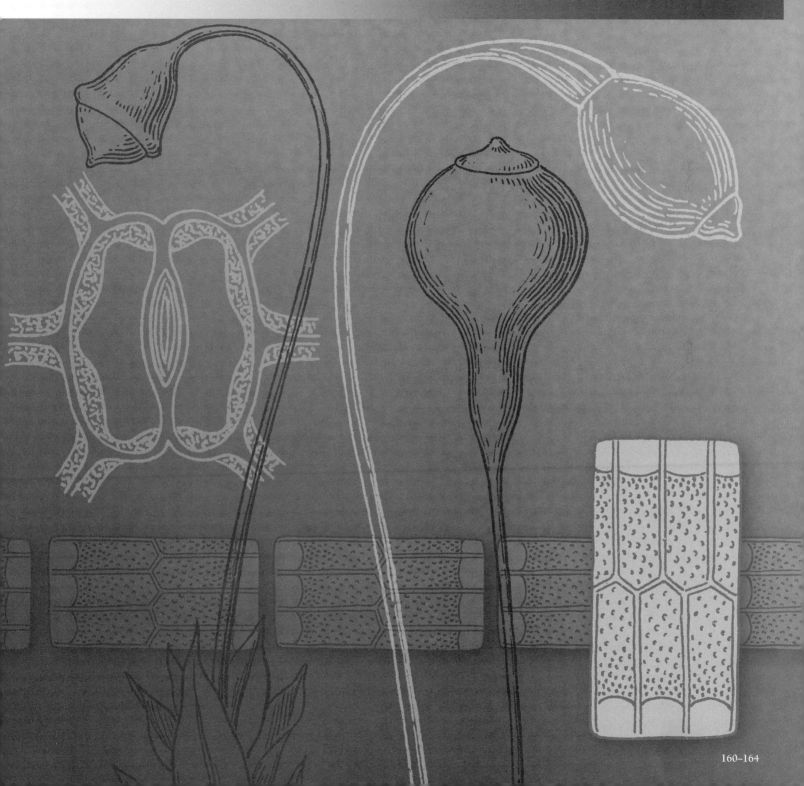

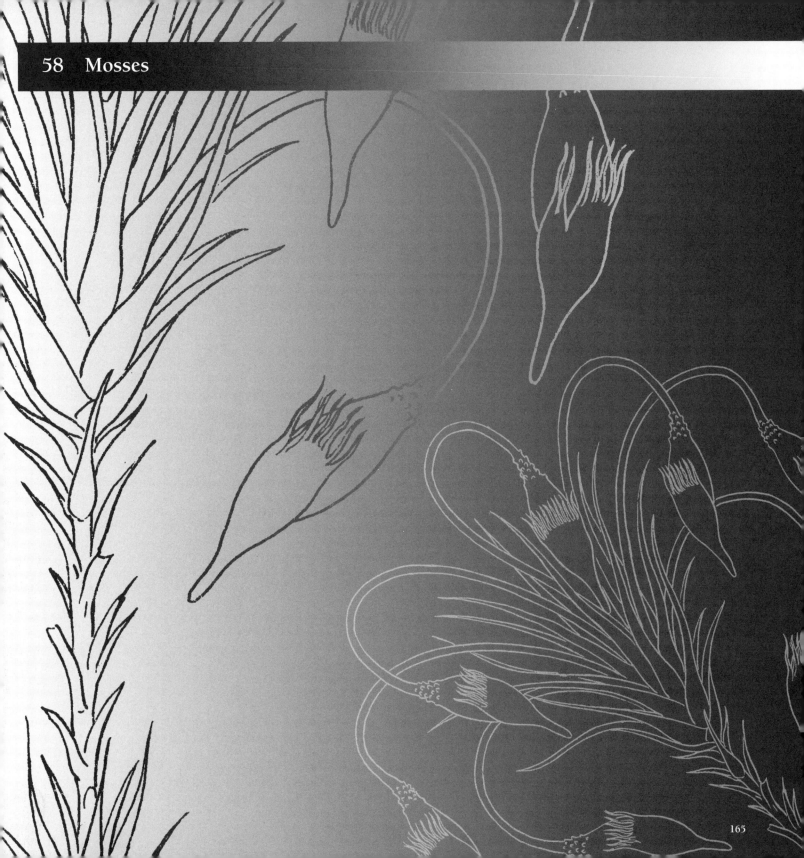

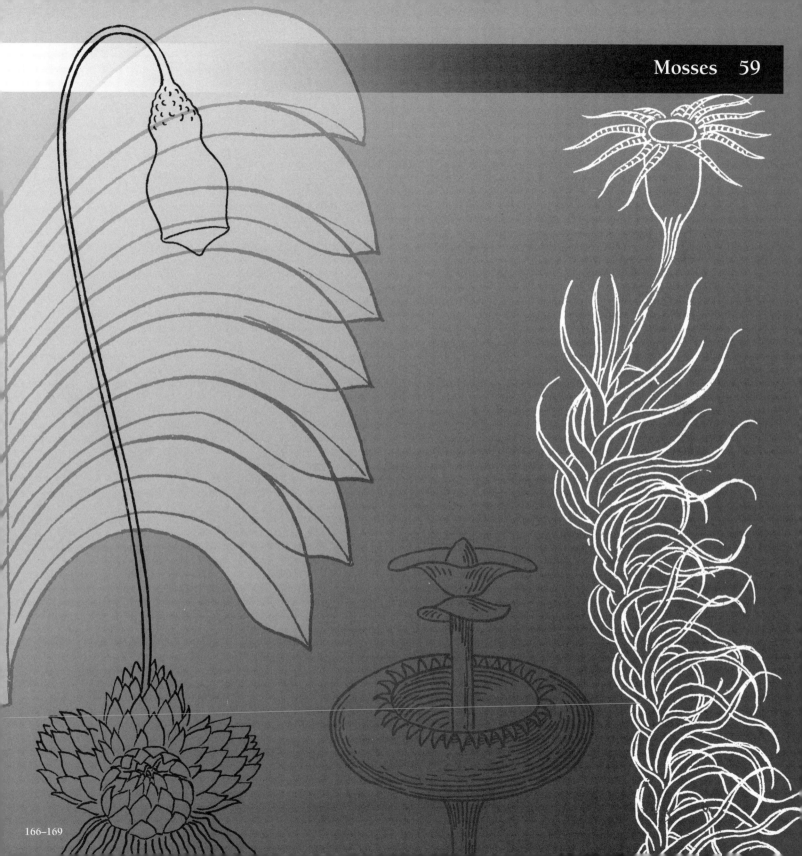

166–169

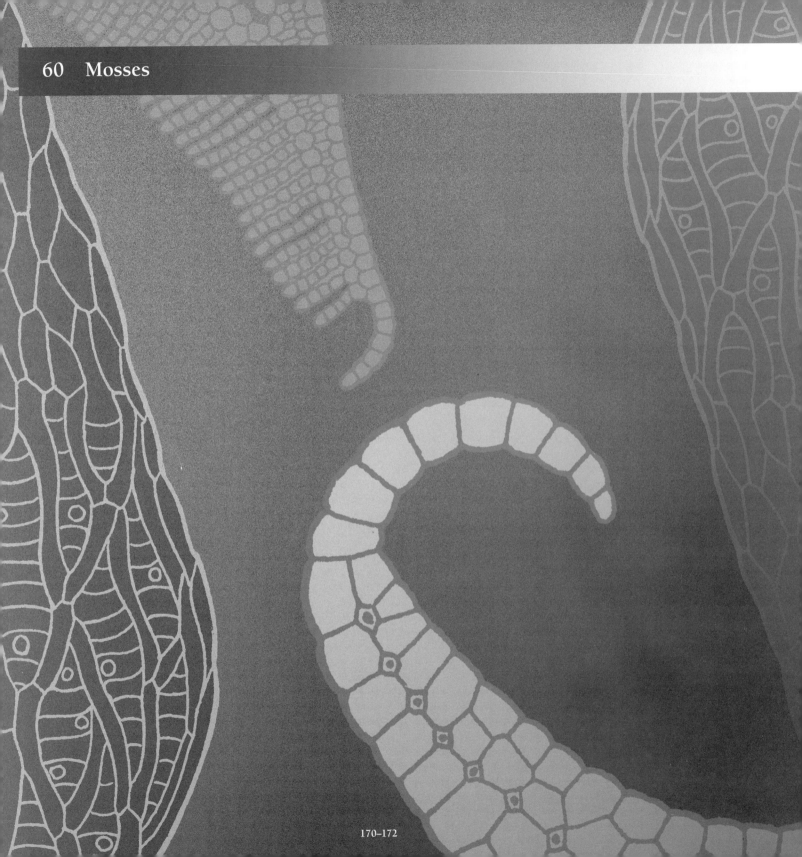

170–172

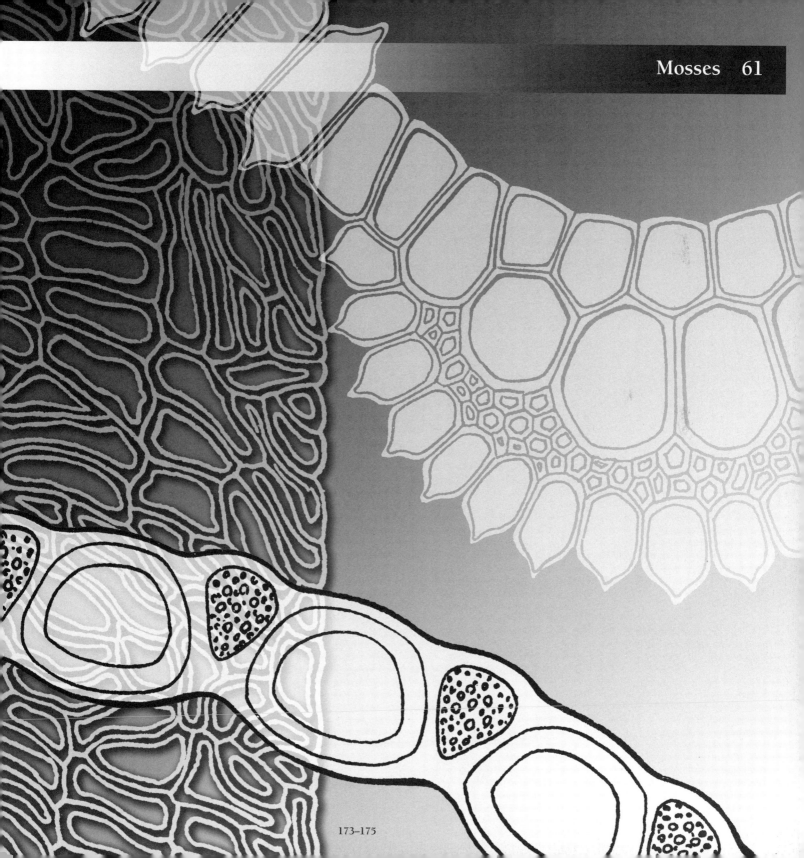

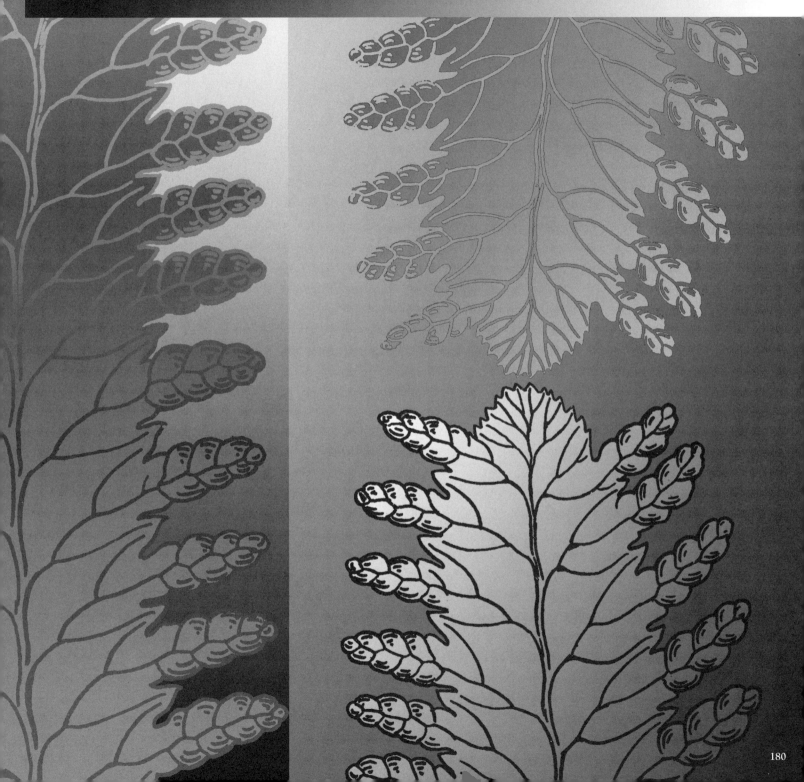

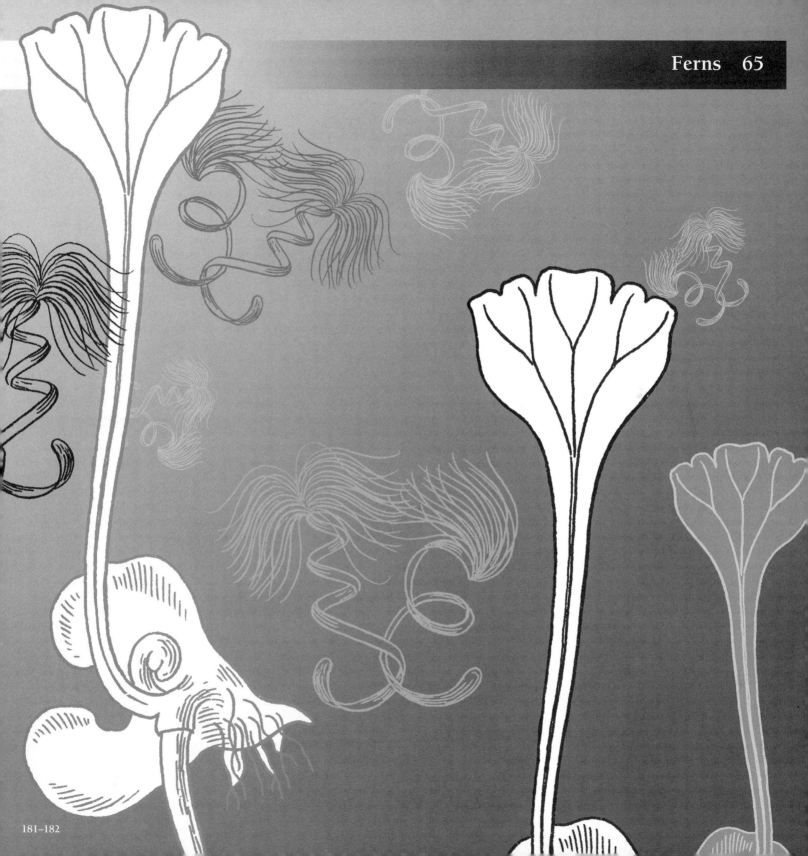

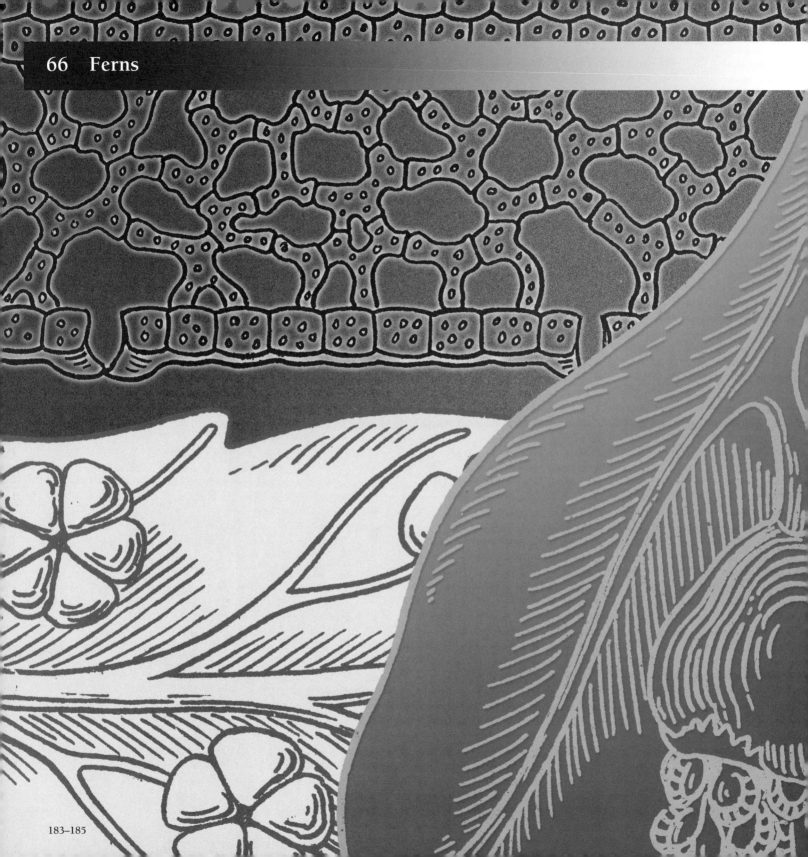

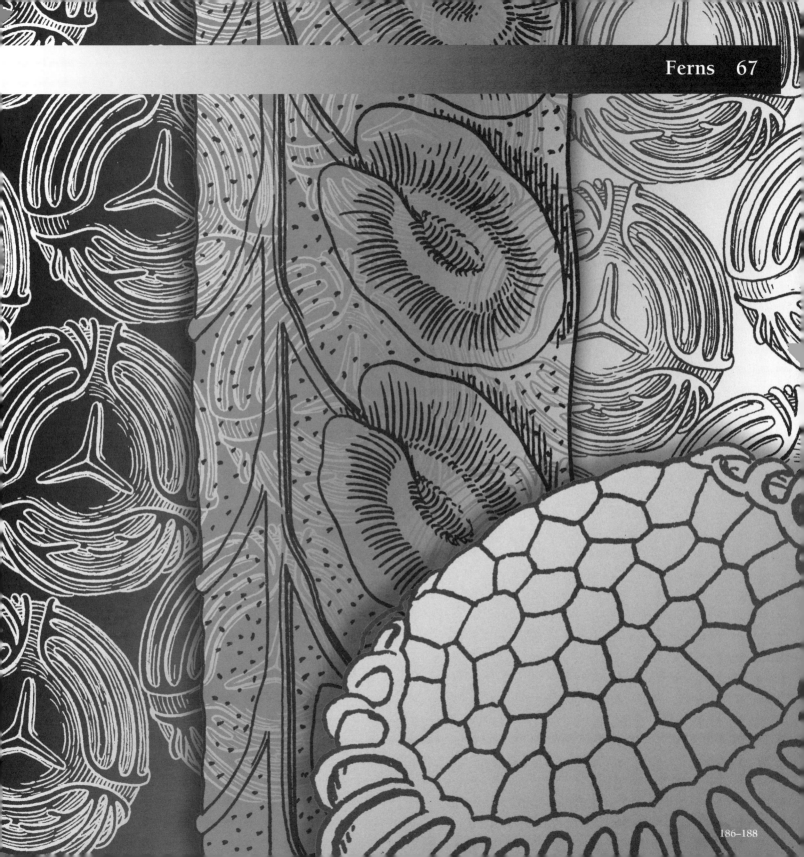

189–191

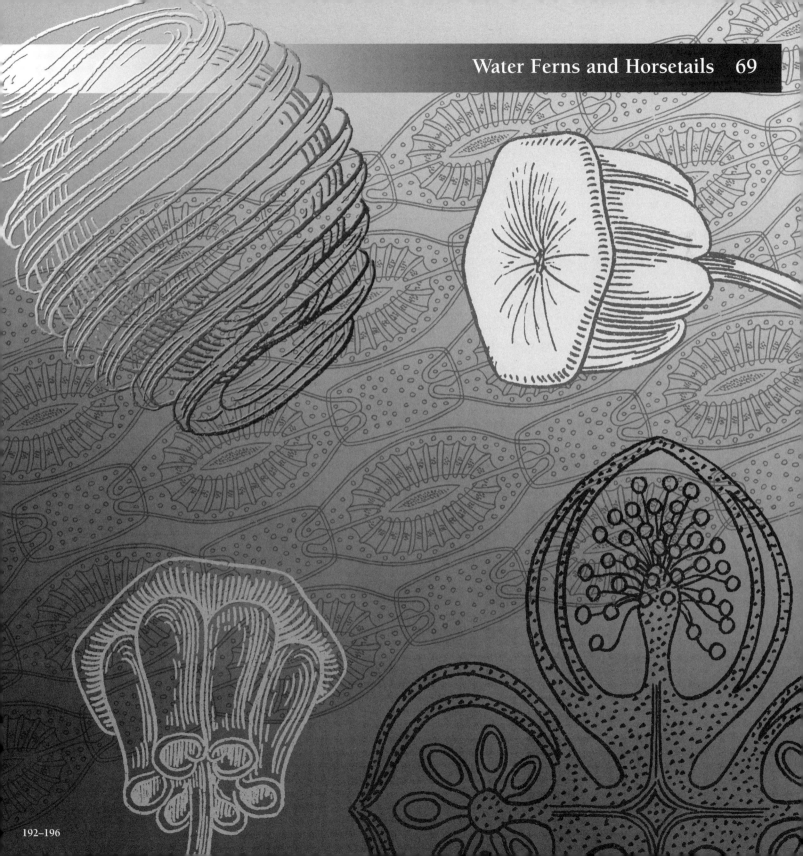

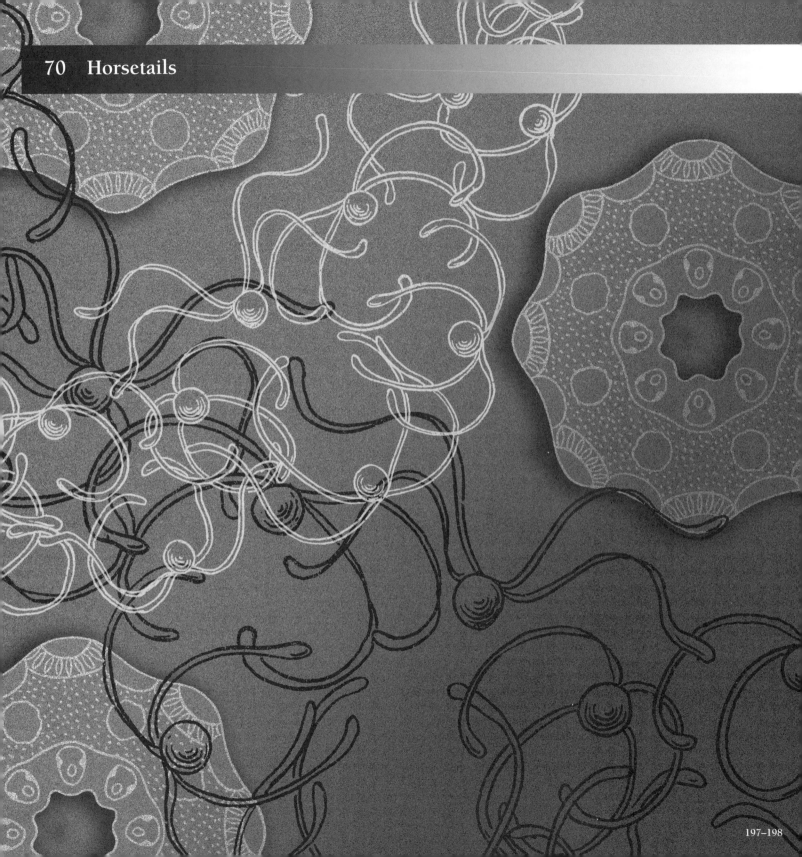

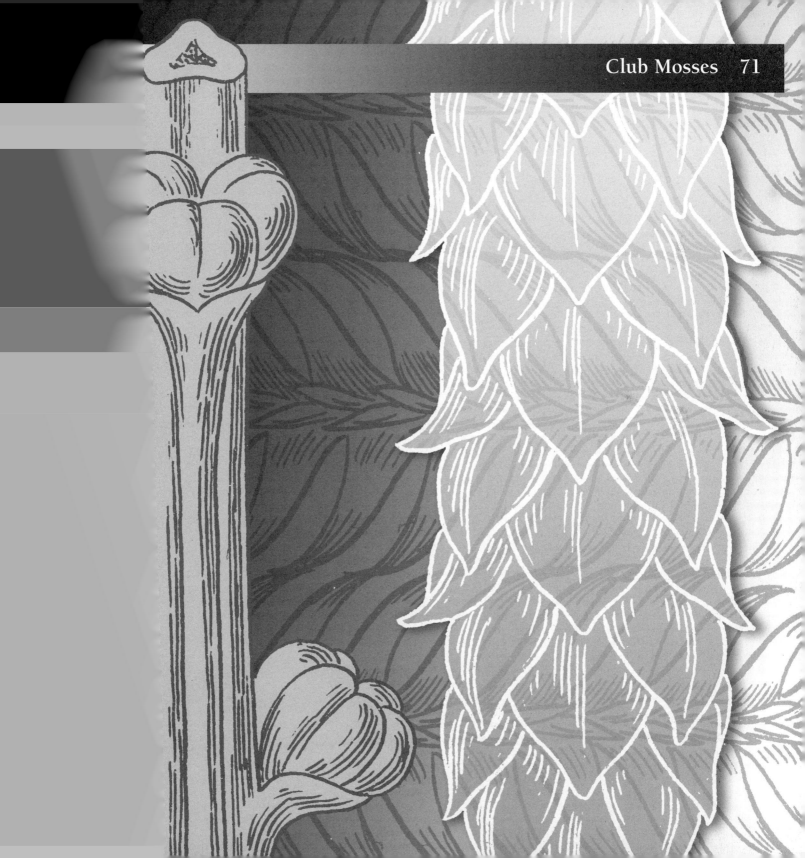

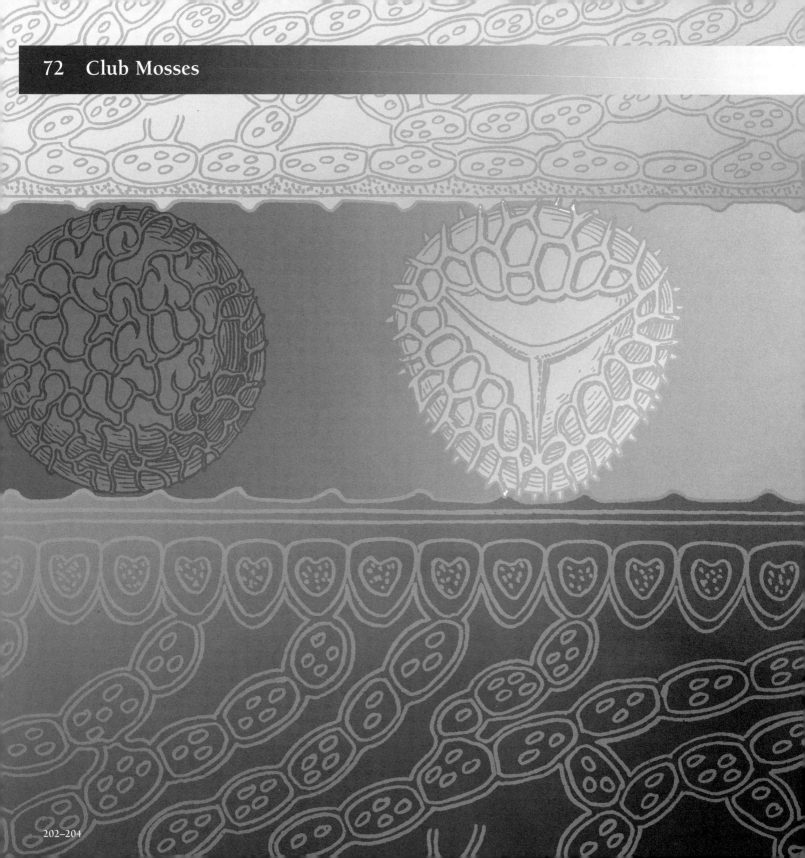

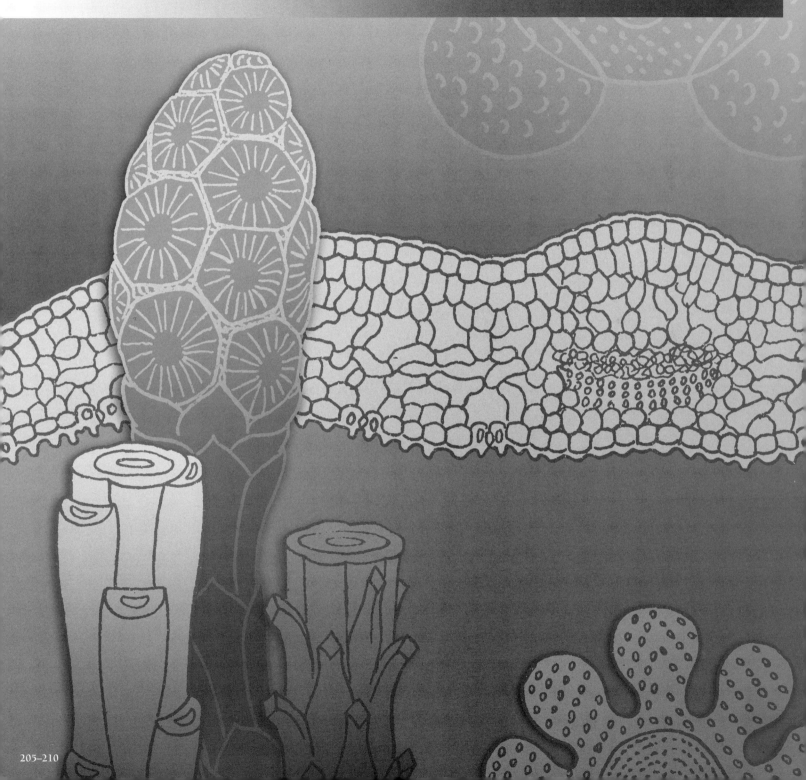

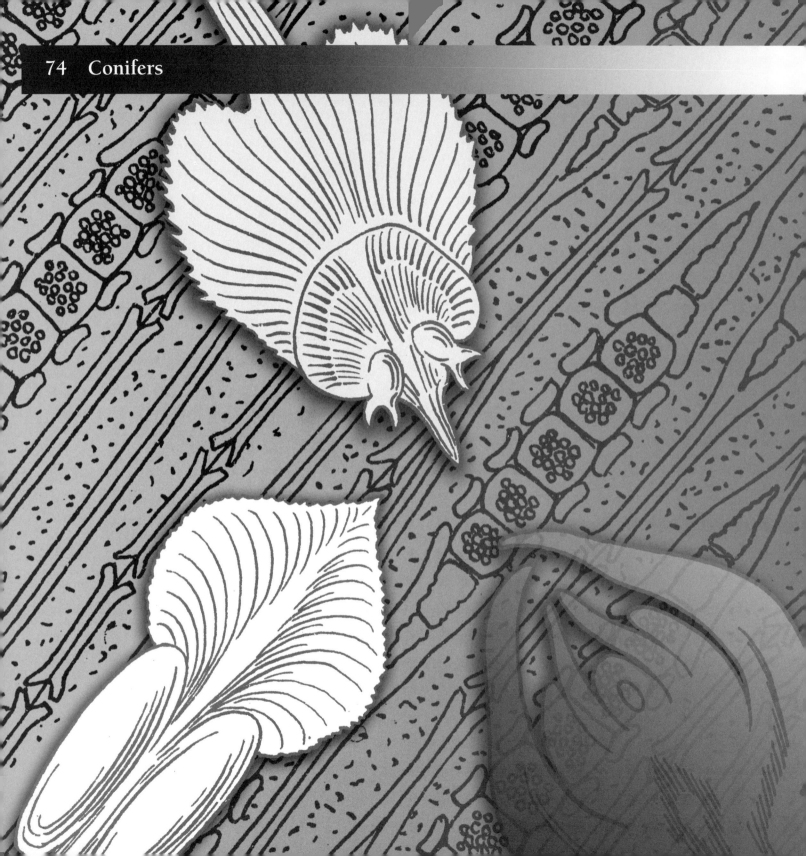

211–216

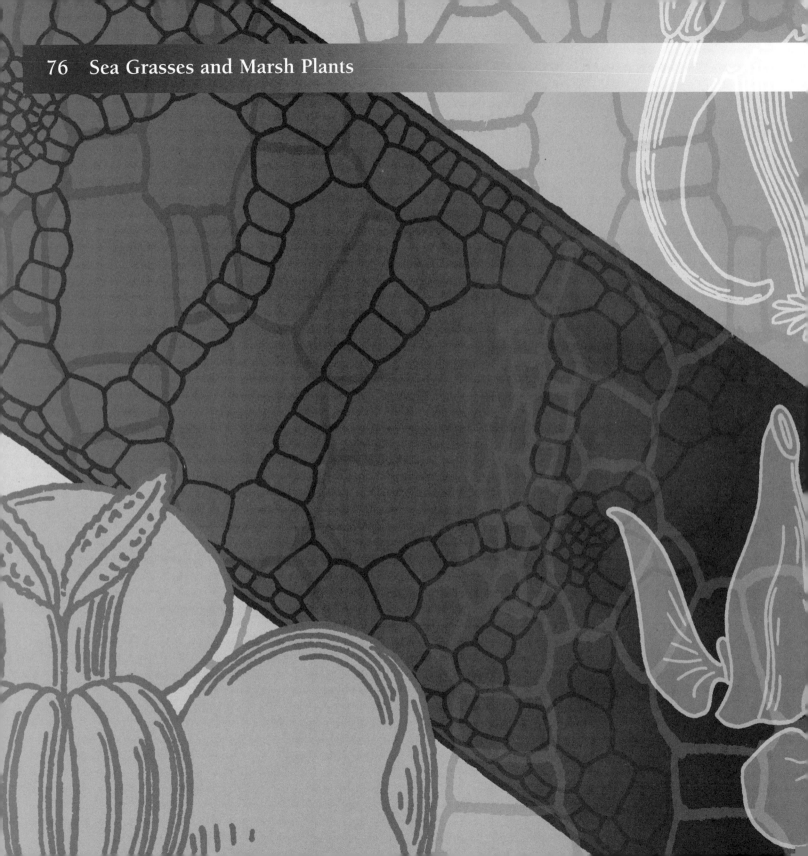

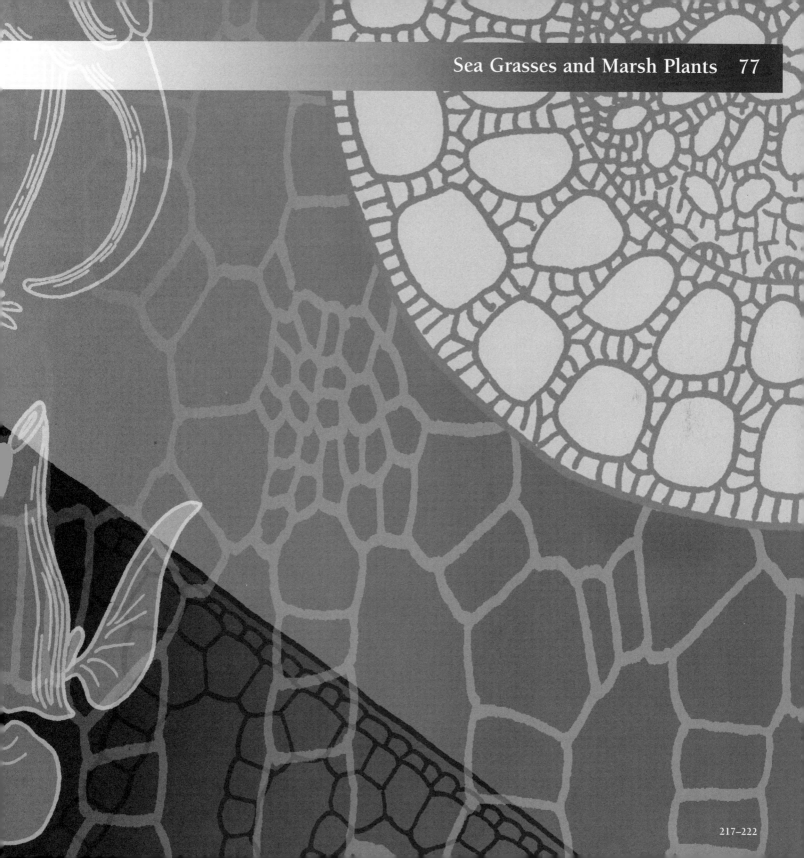

217–222

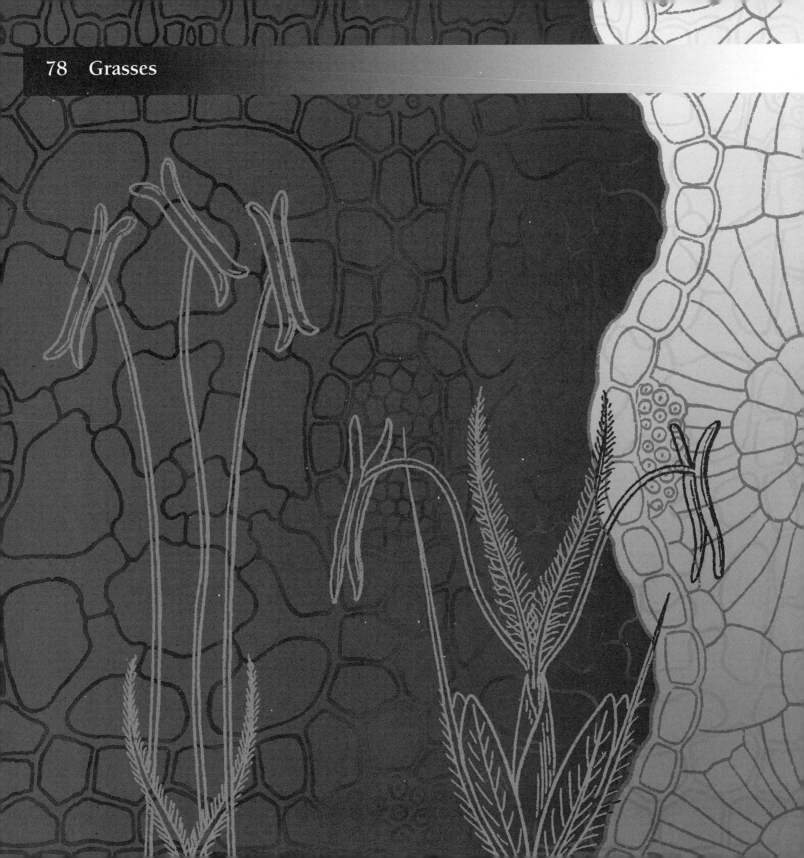

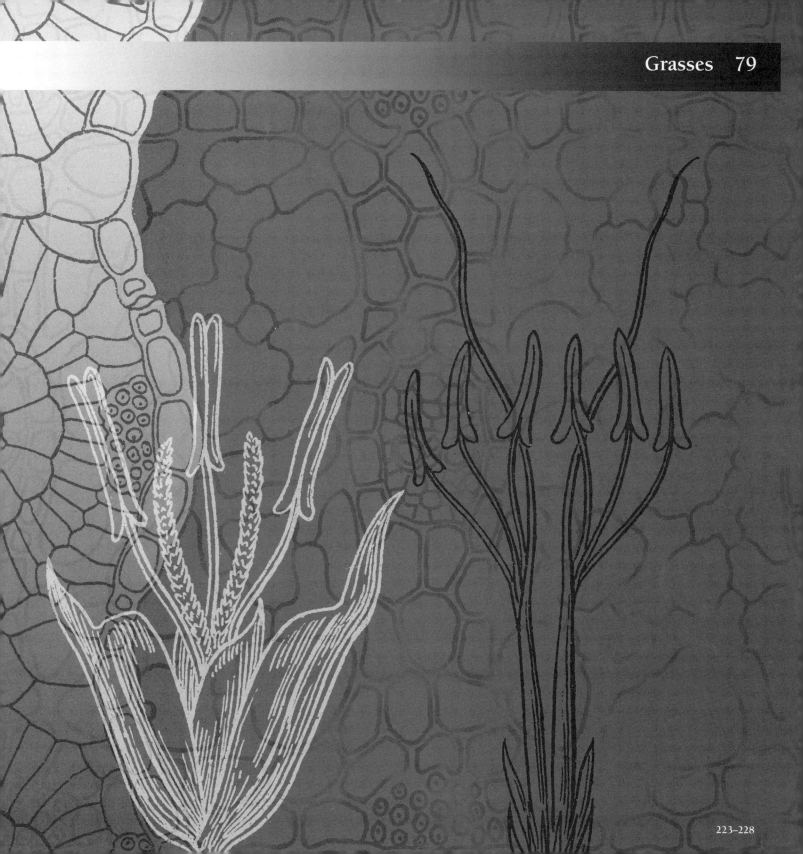

223–228

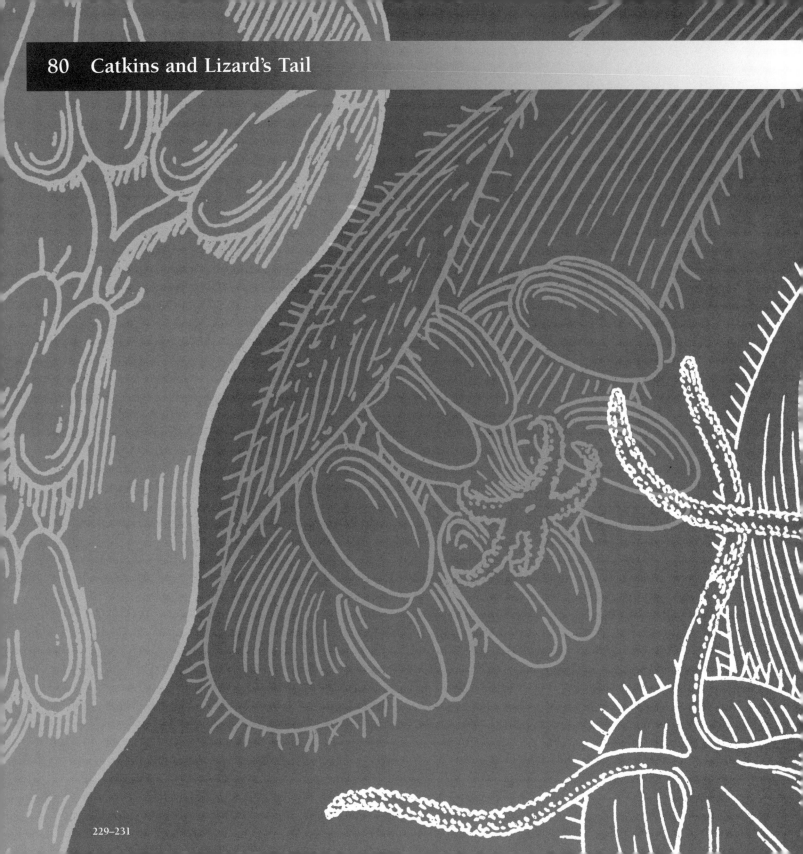

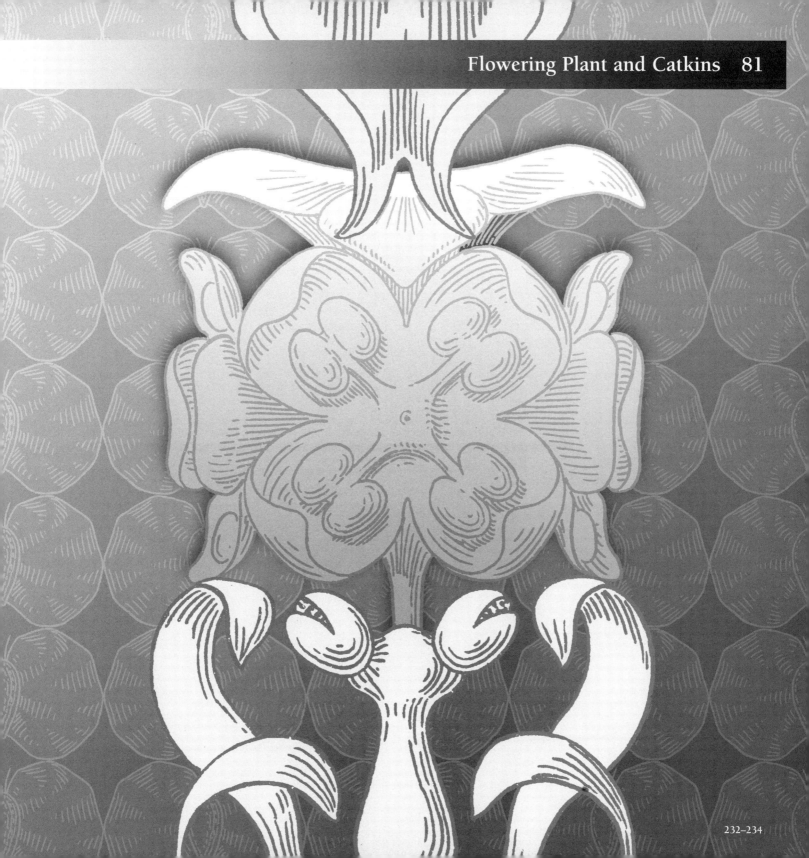

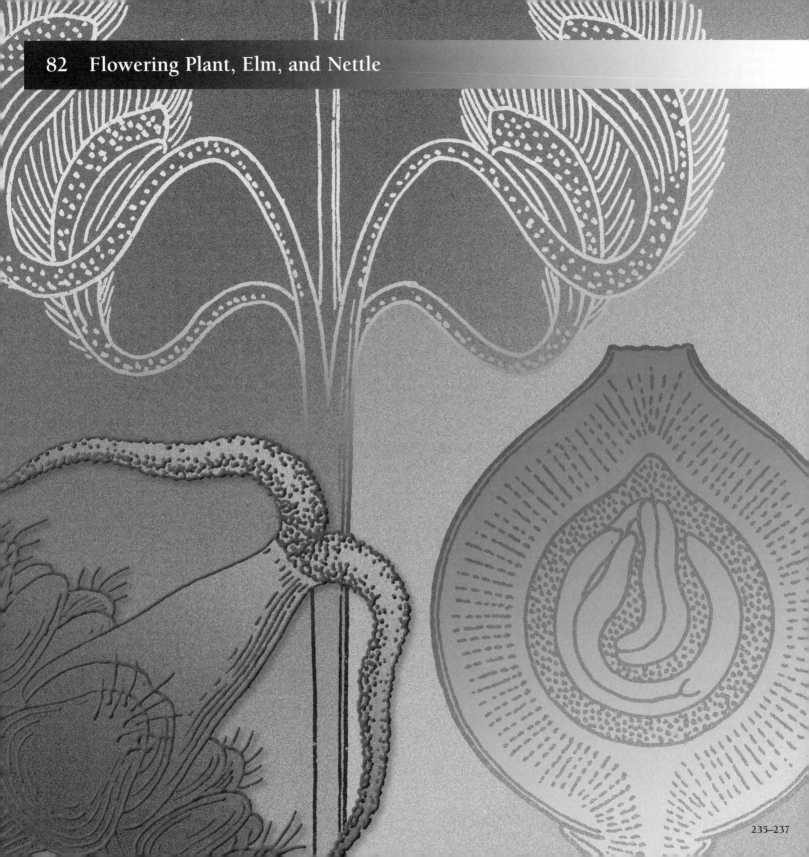

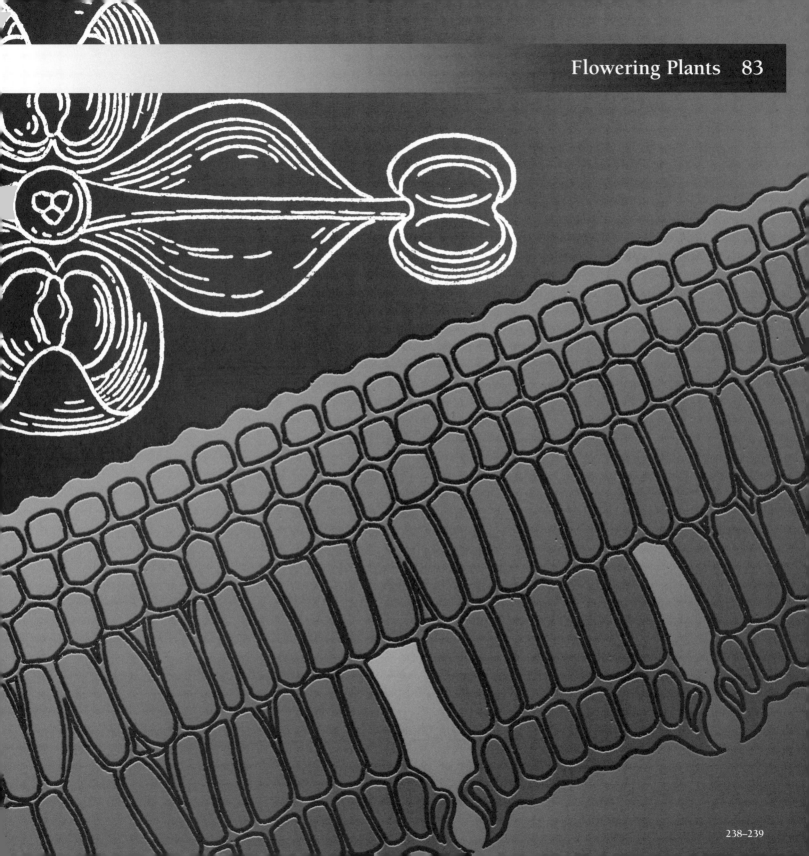

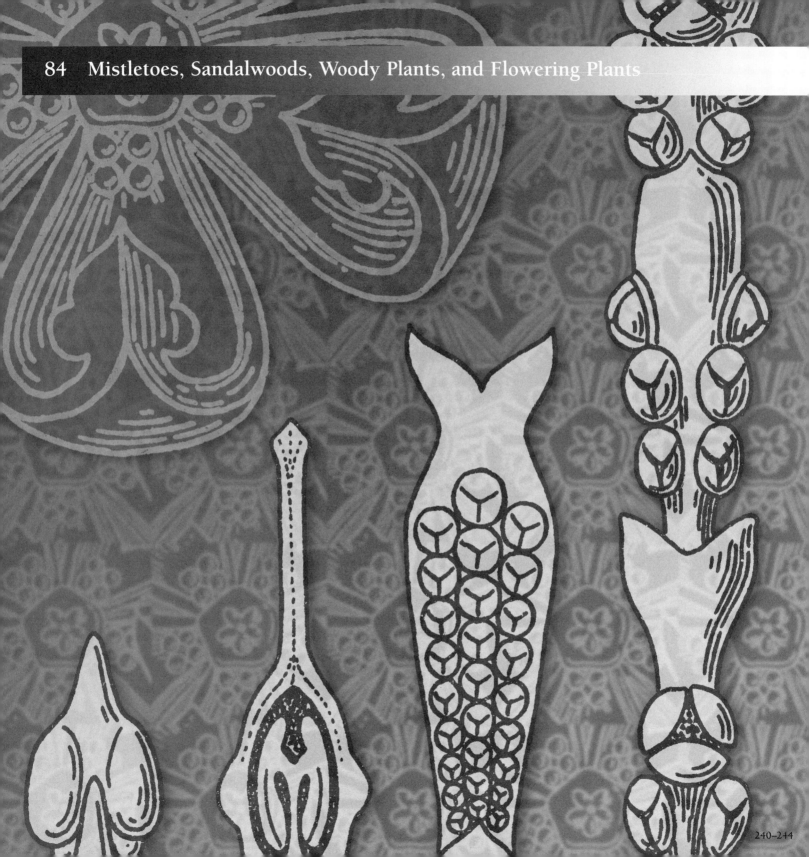

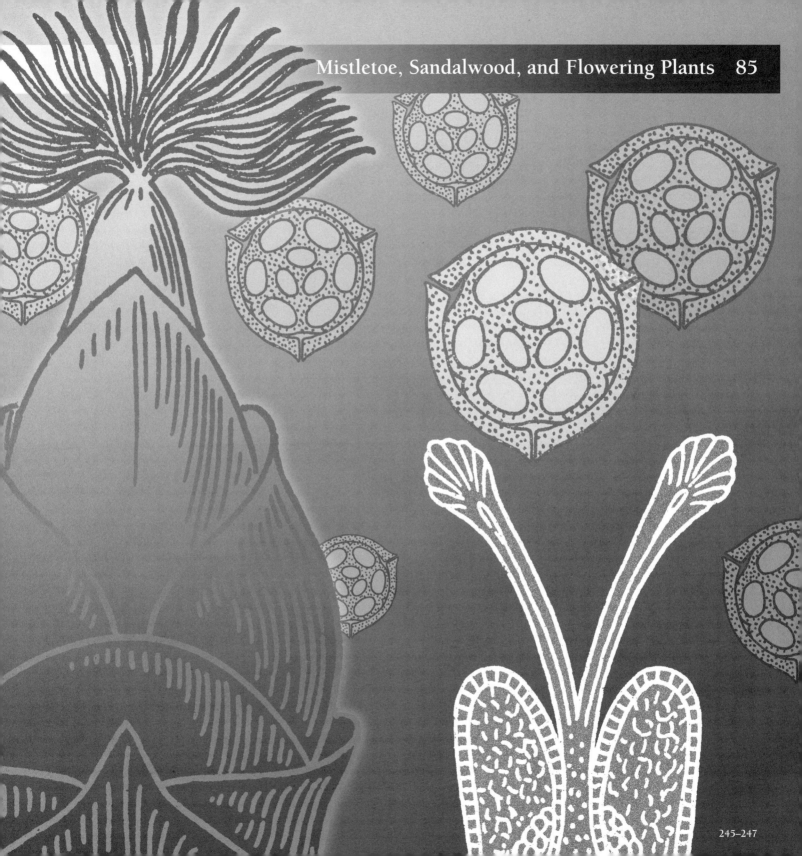

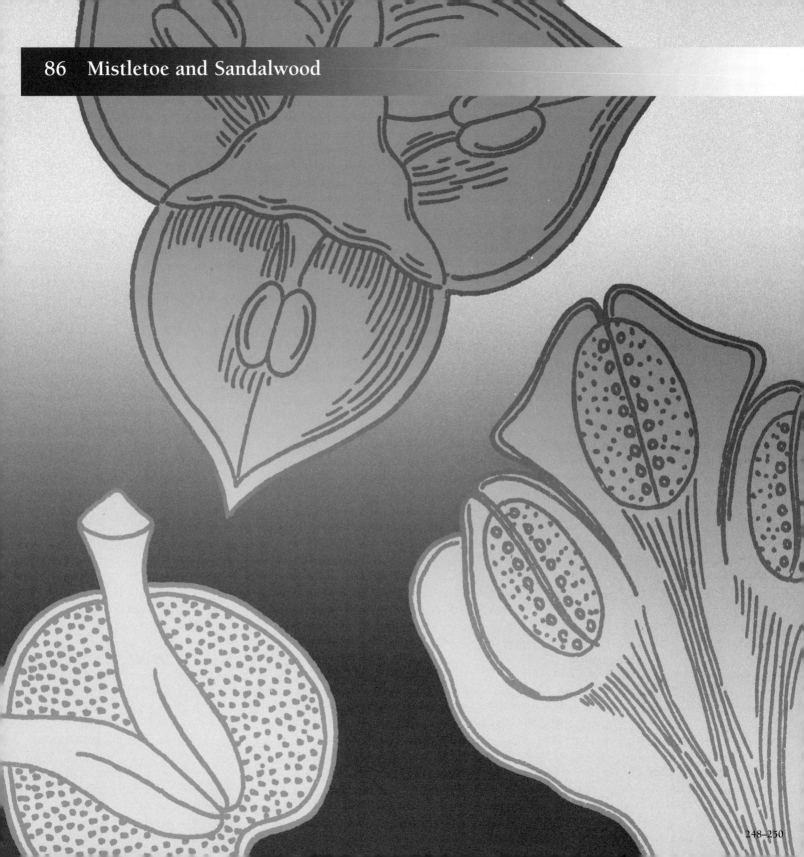

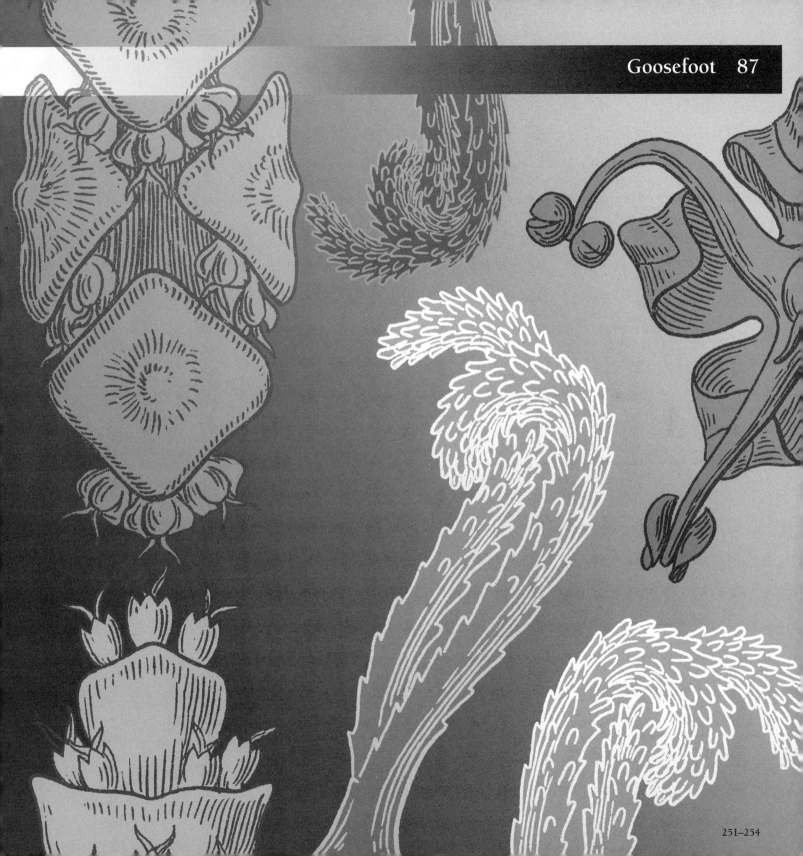

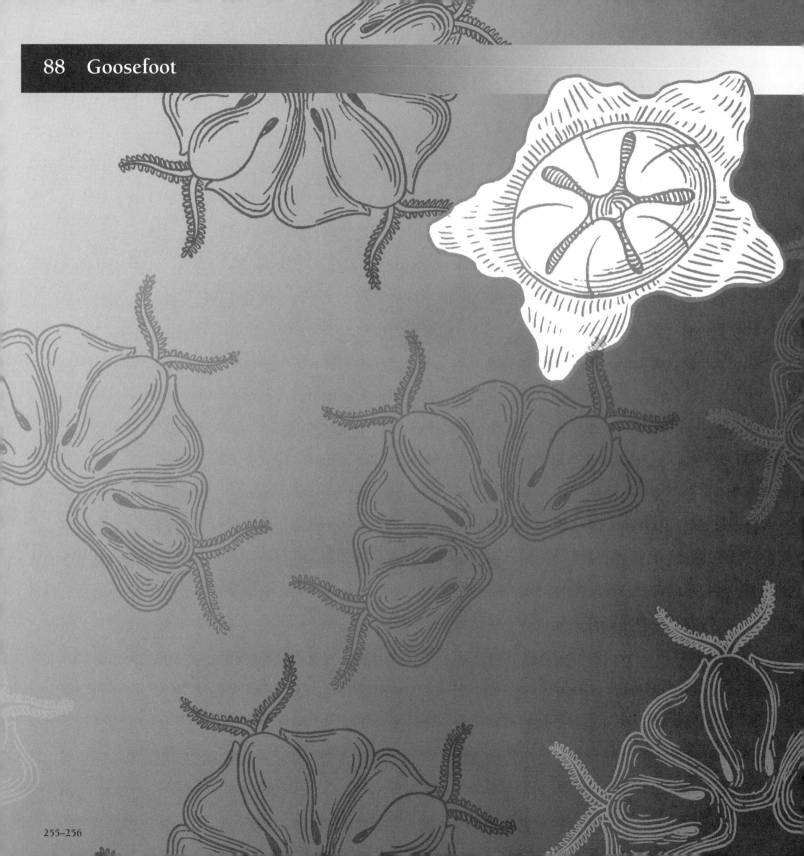

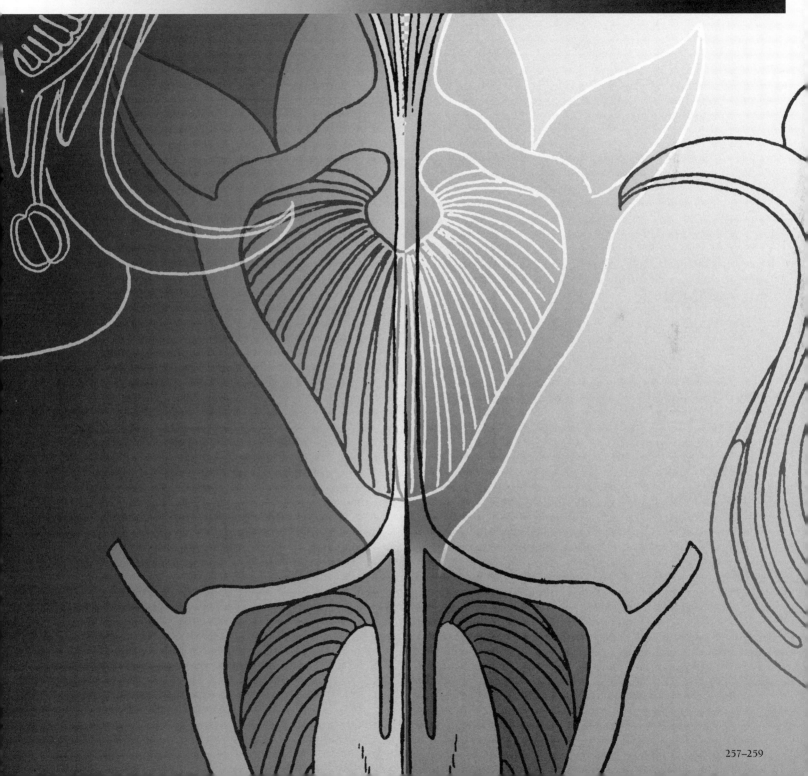

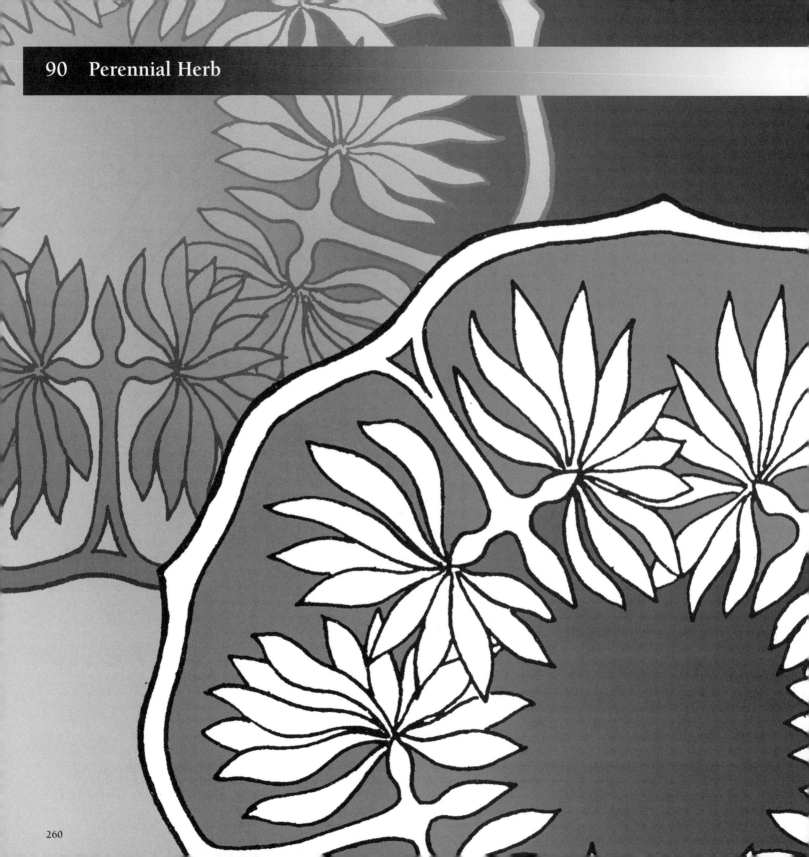

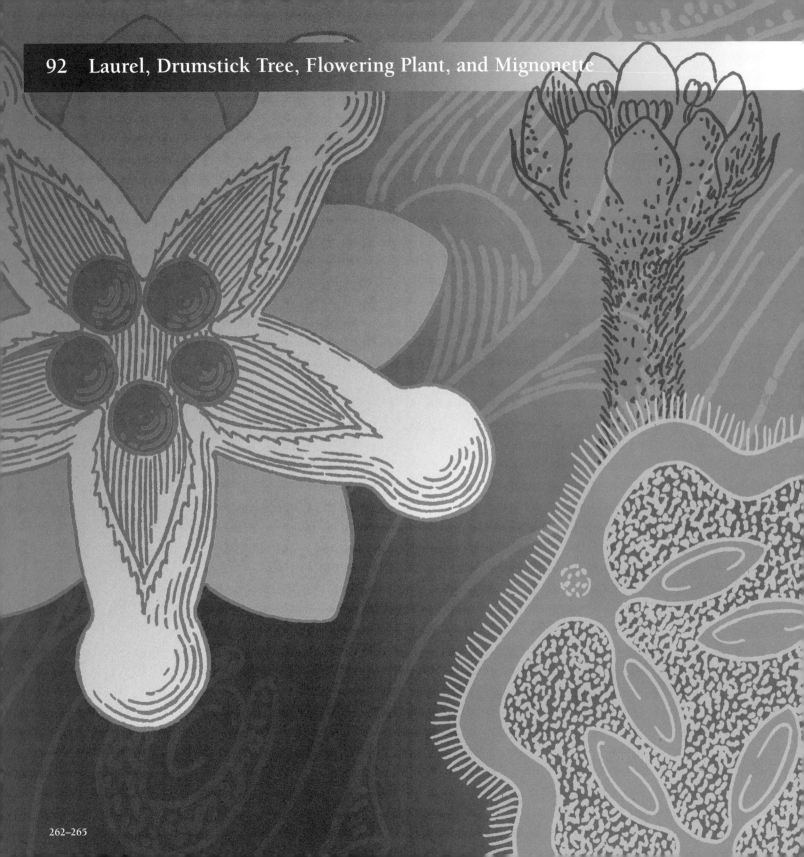

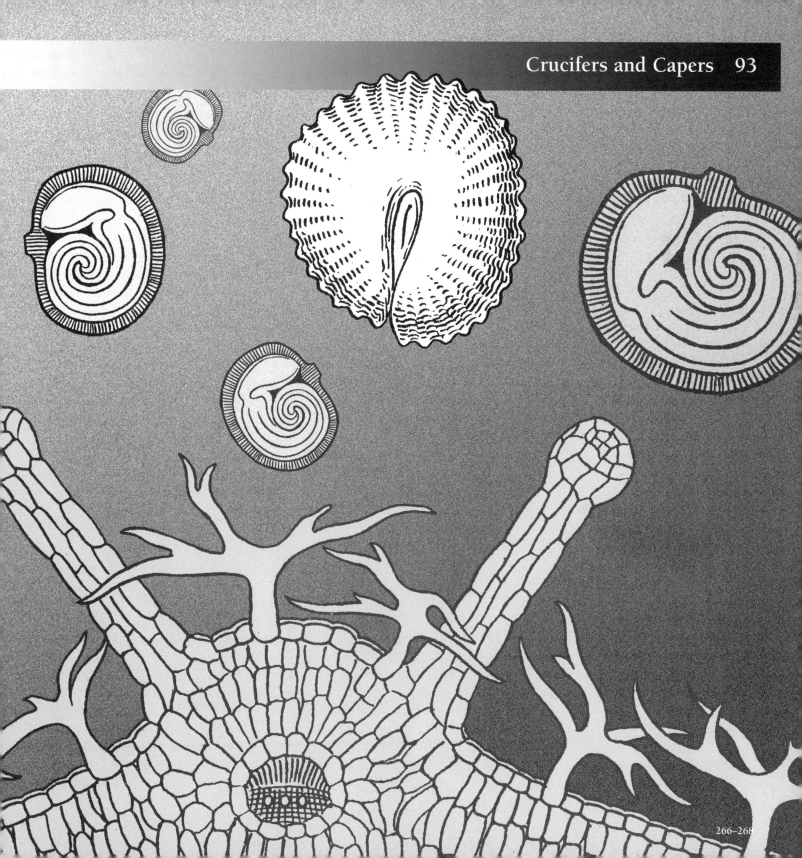

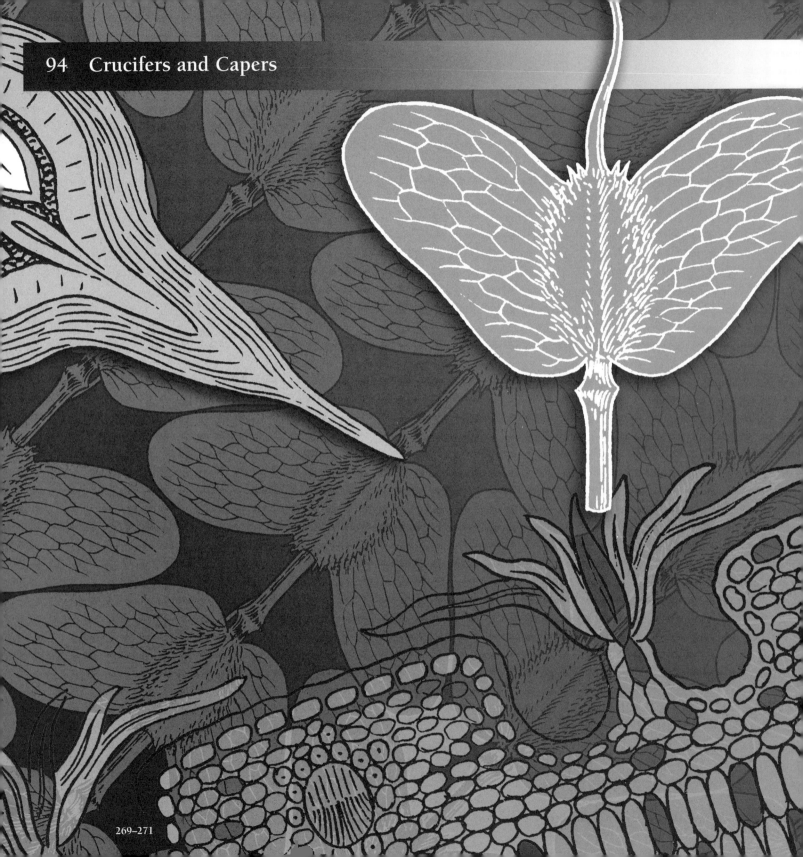

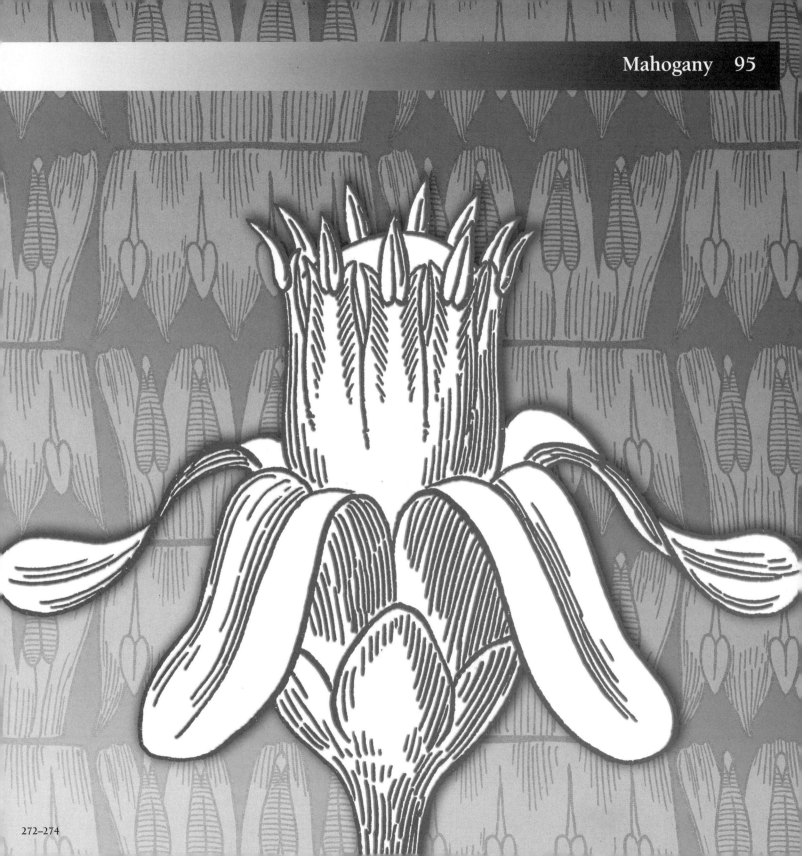

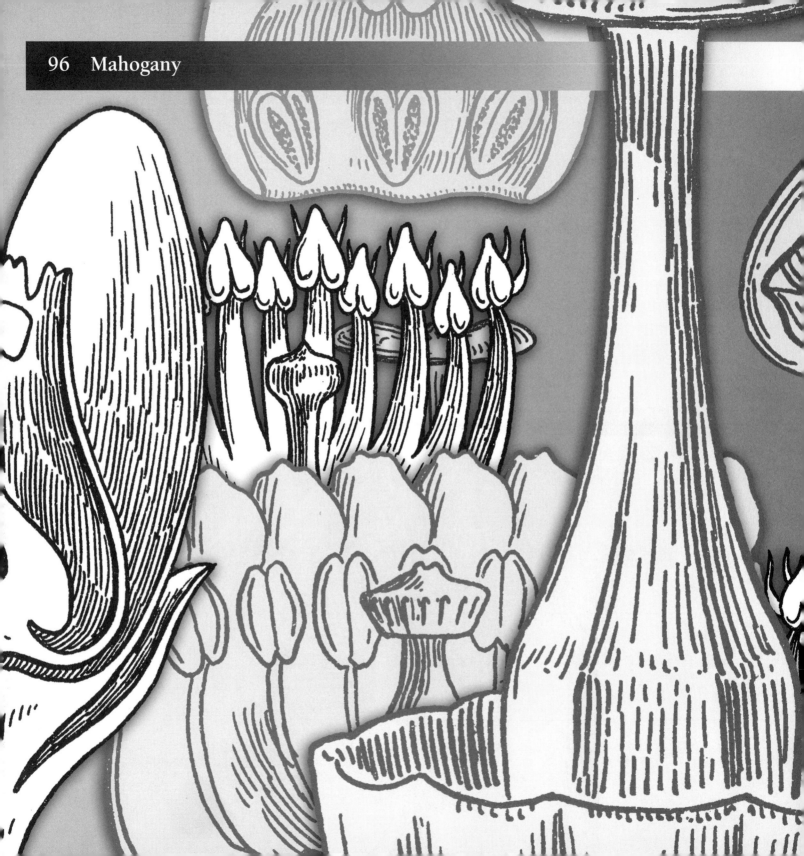

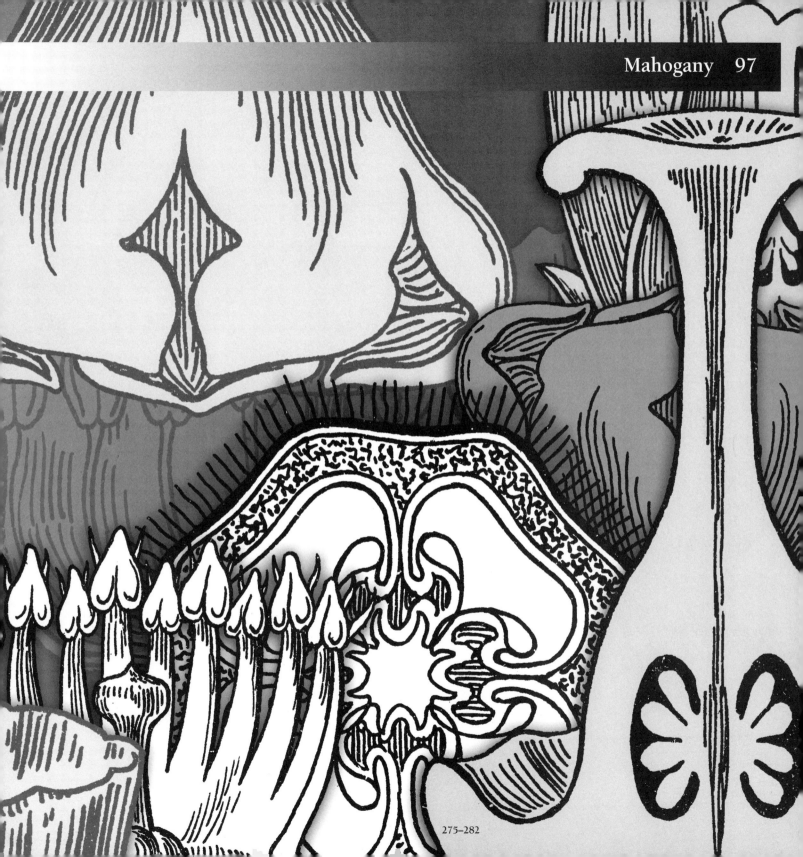

275–282

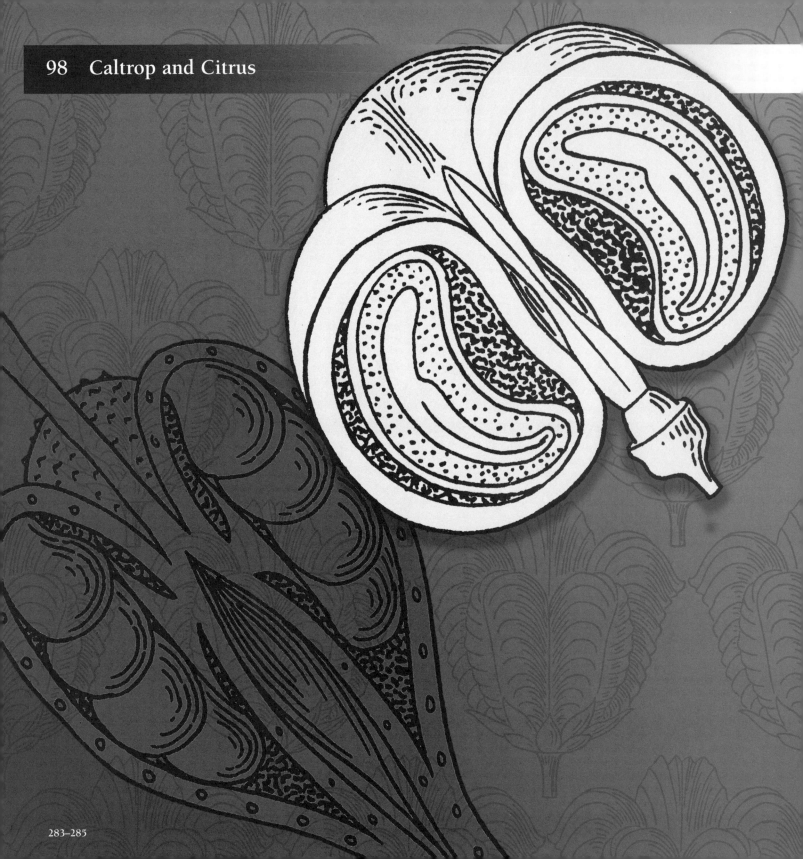

283–285

286–288

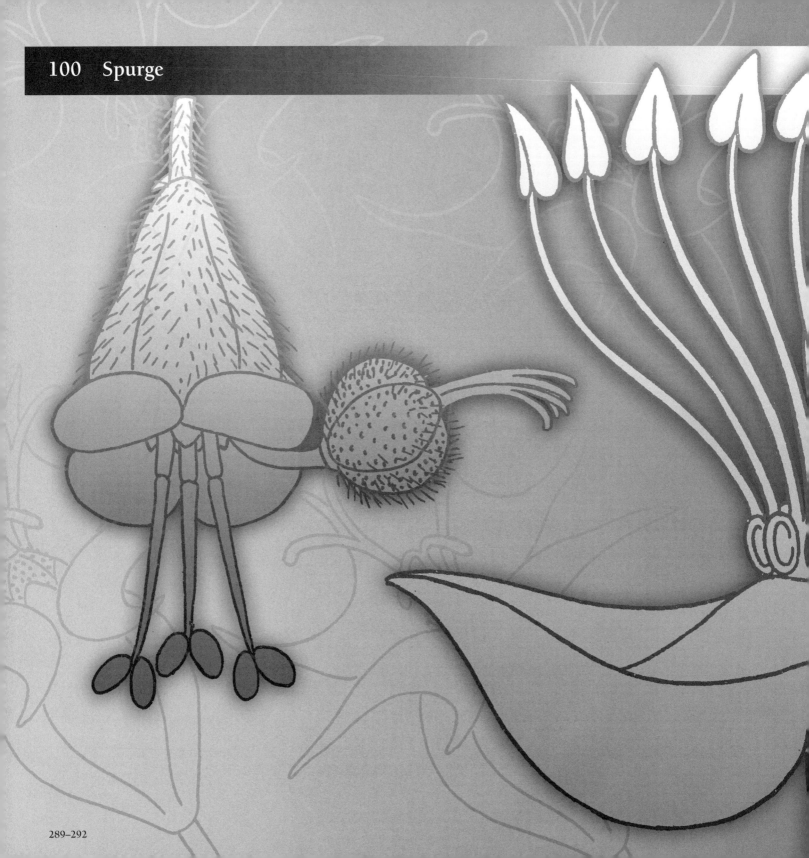

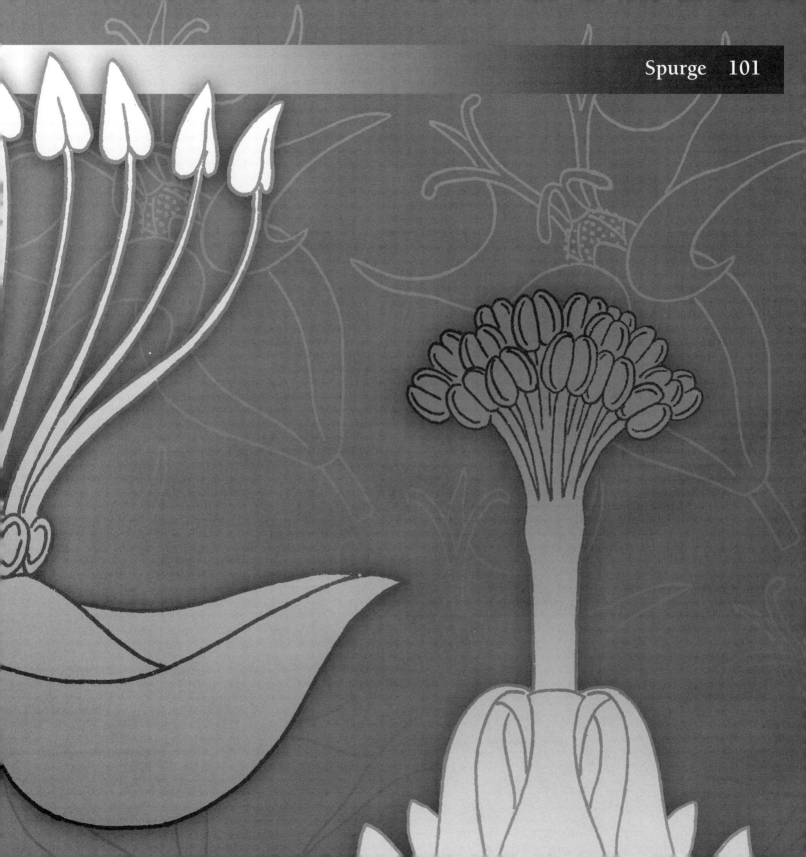

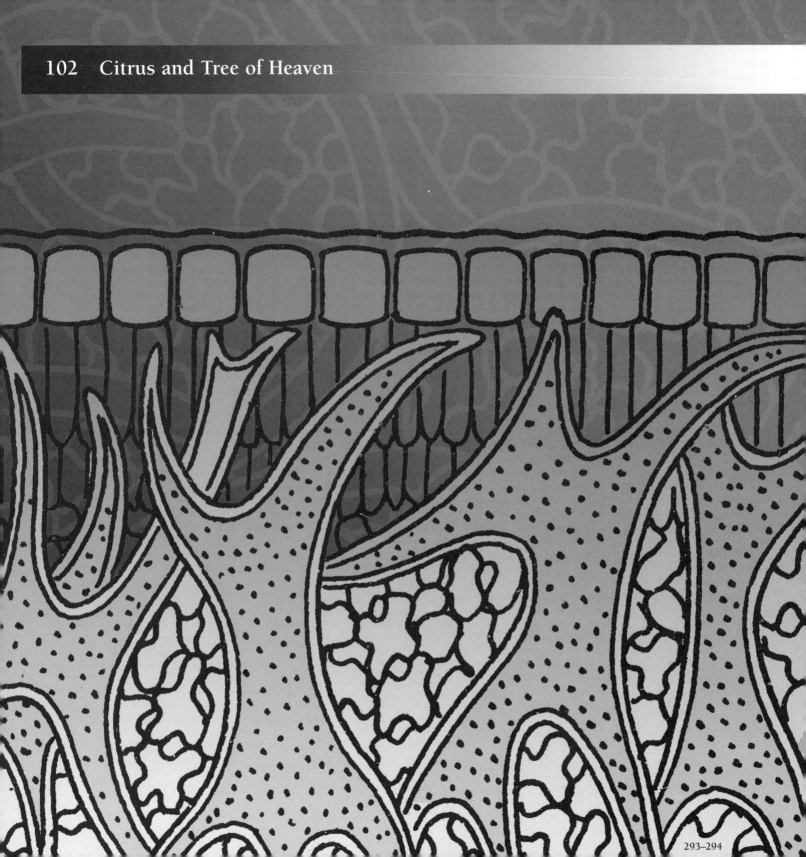

293–294

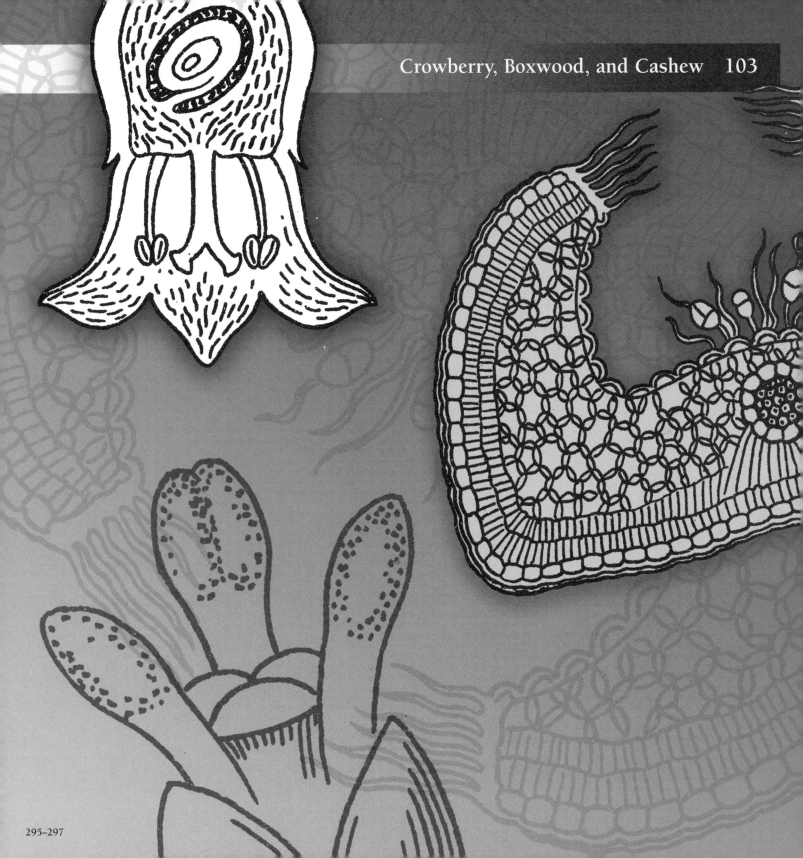

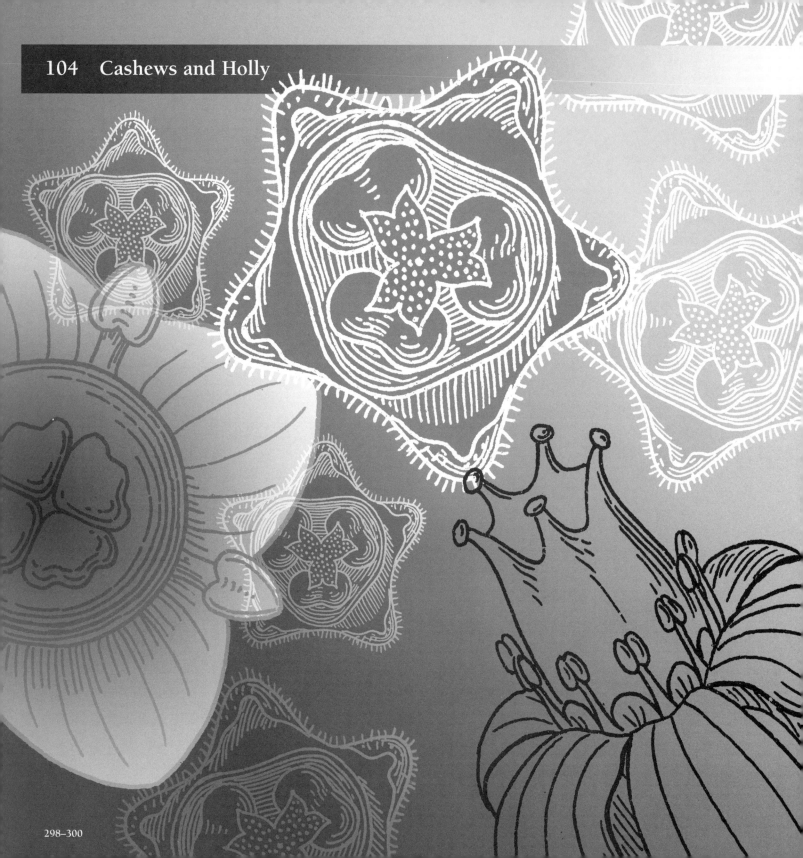

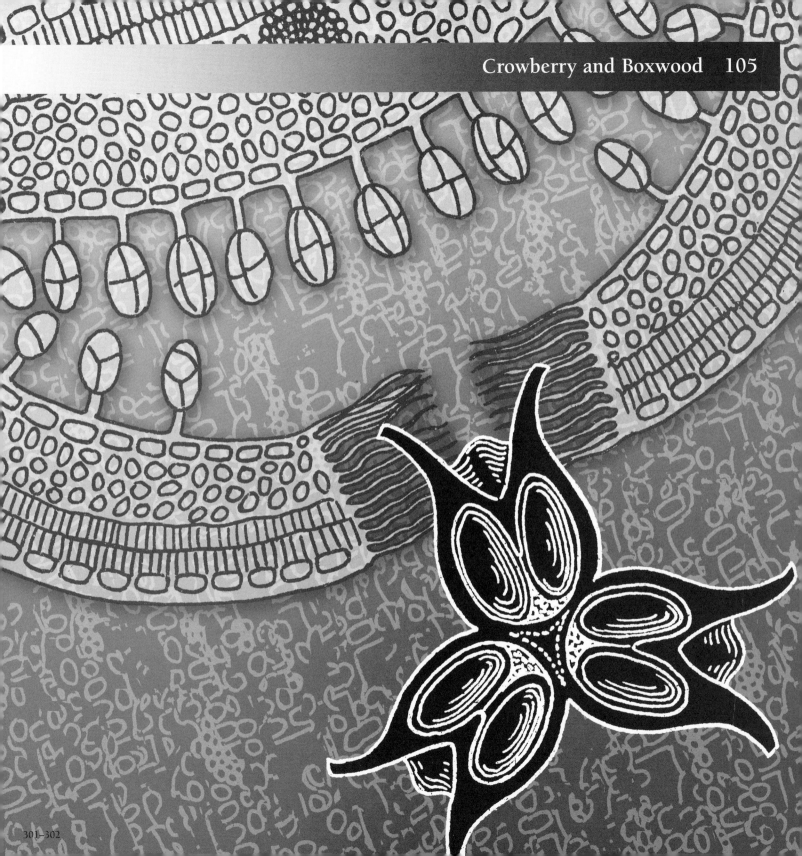

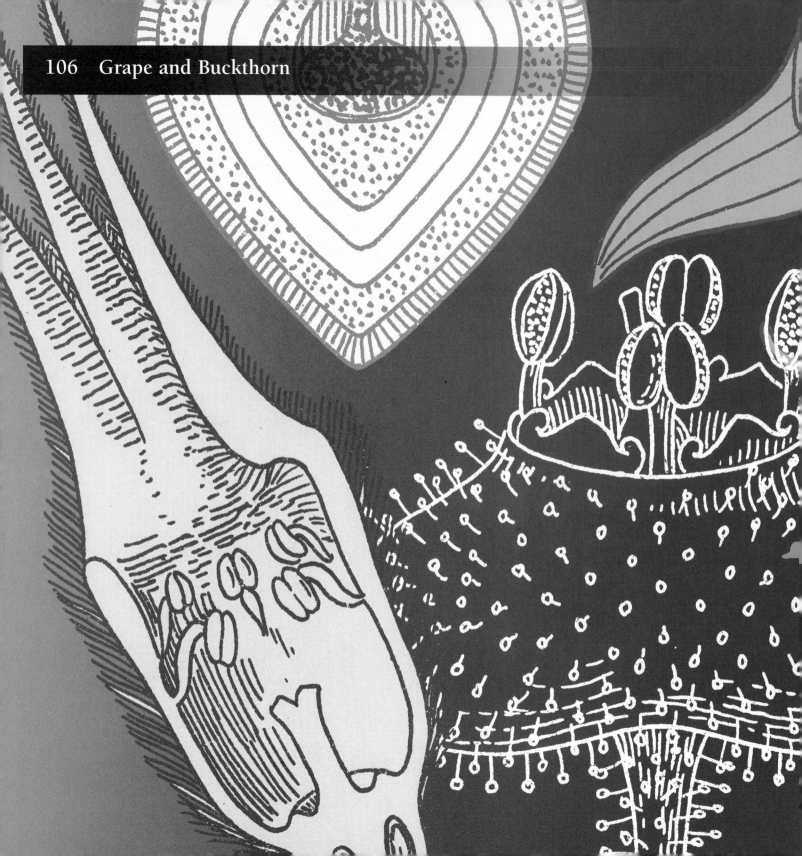

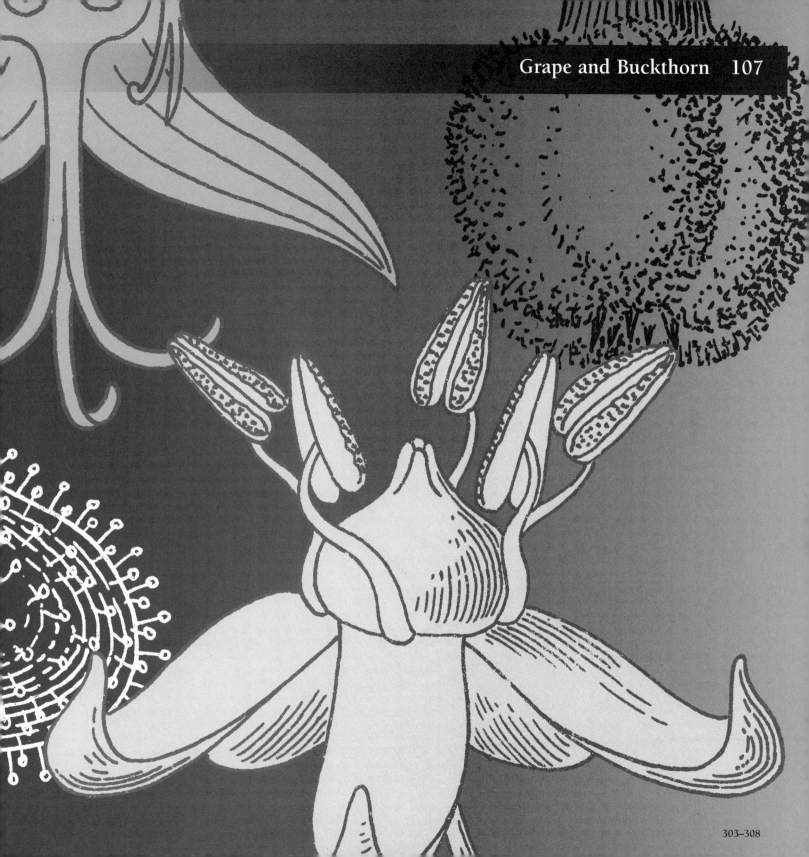

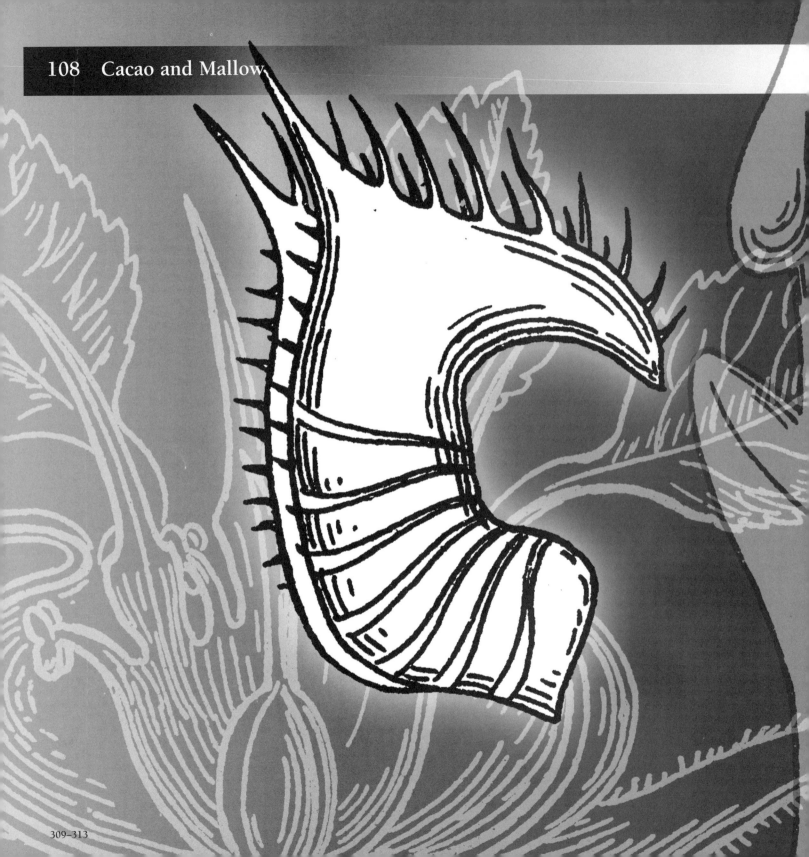

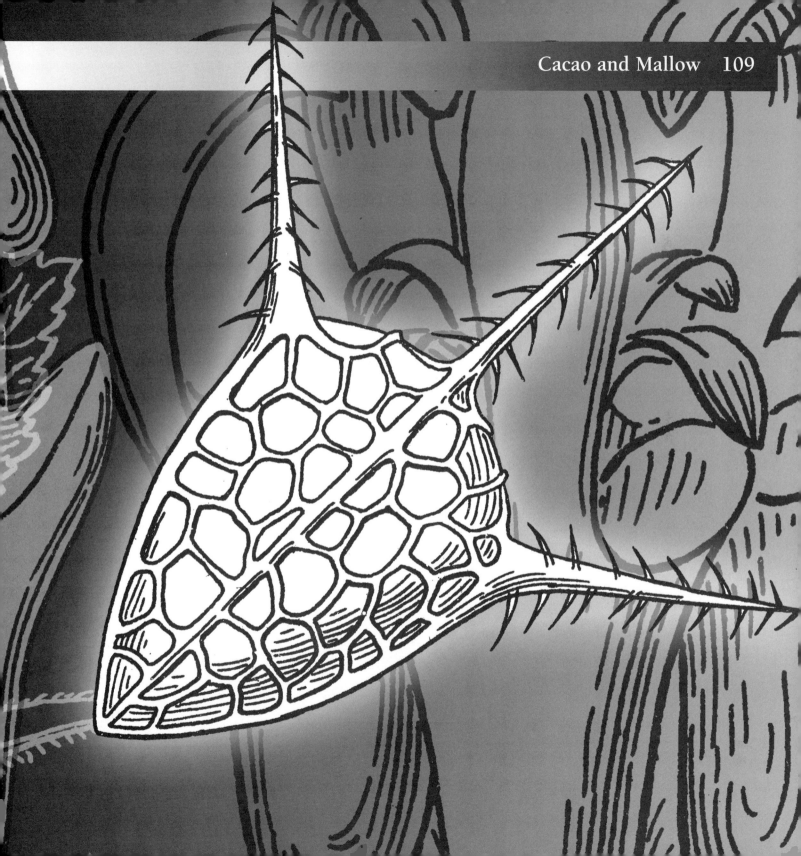

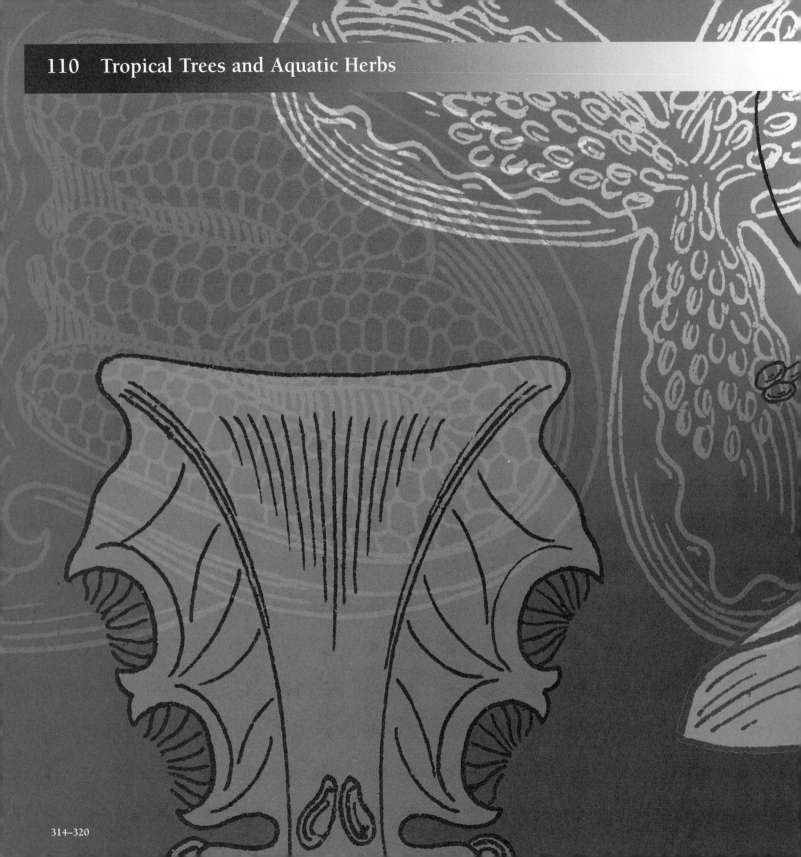

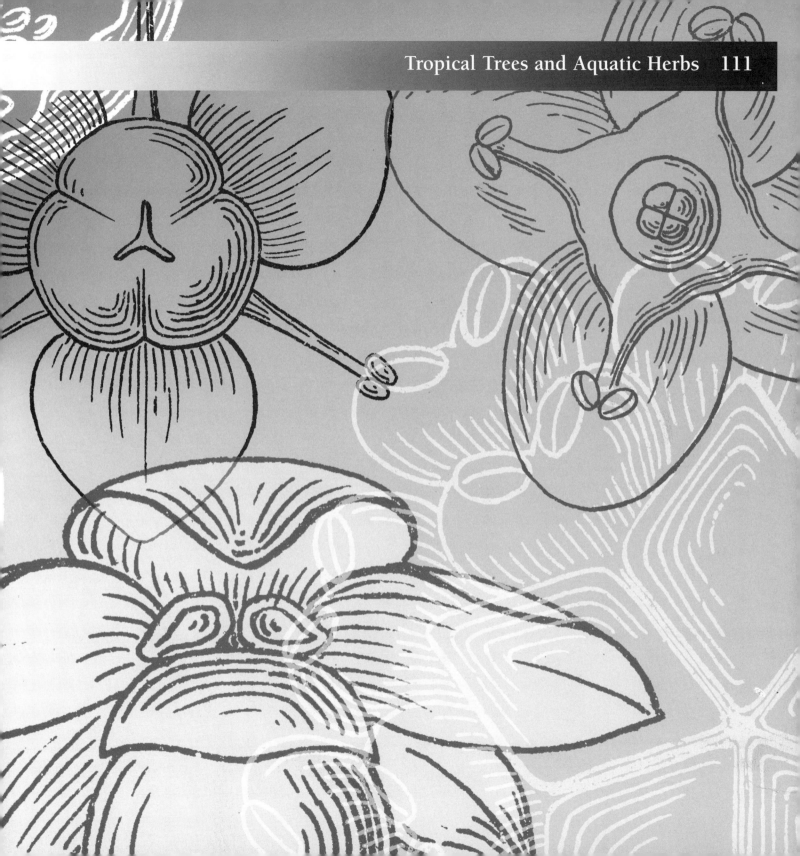

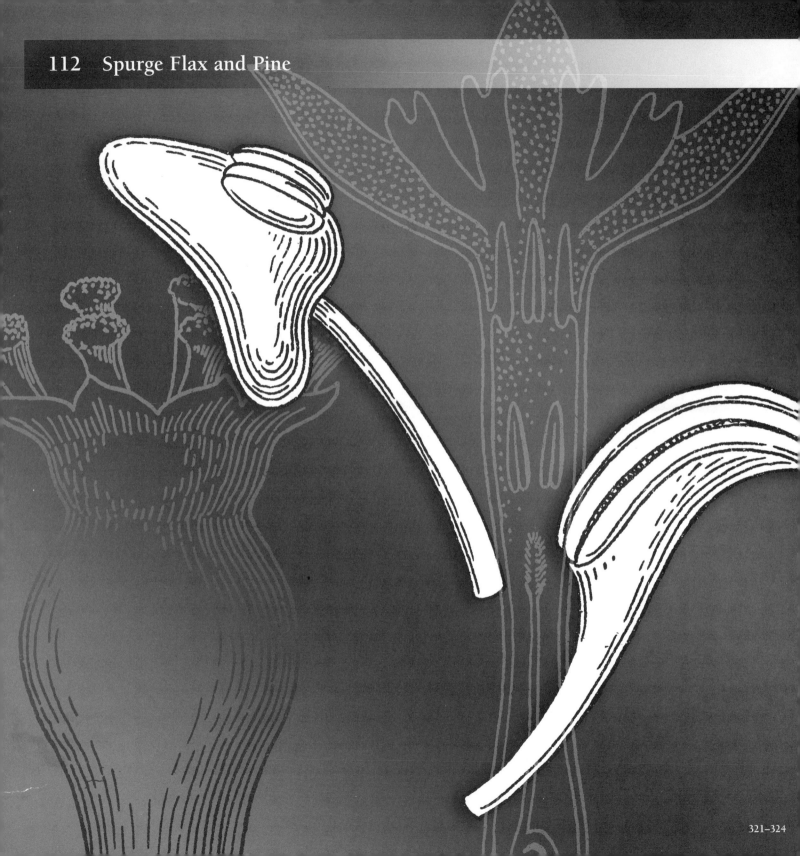

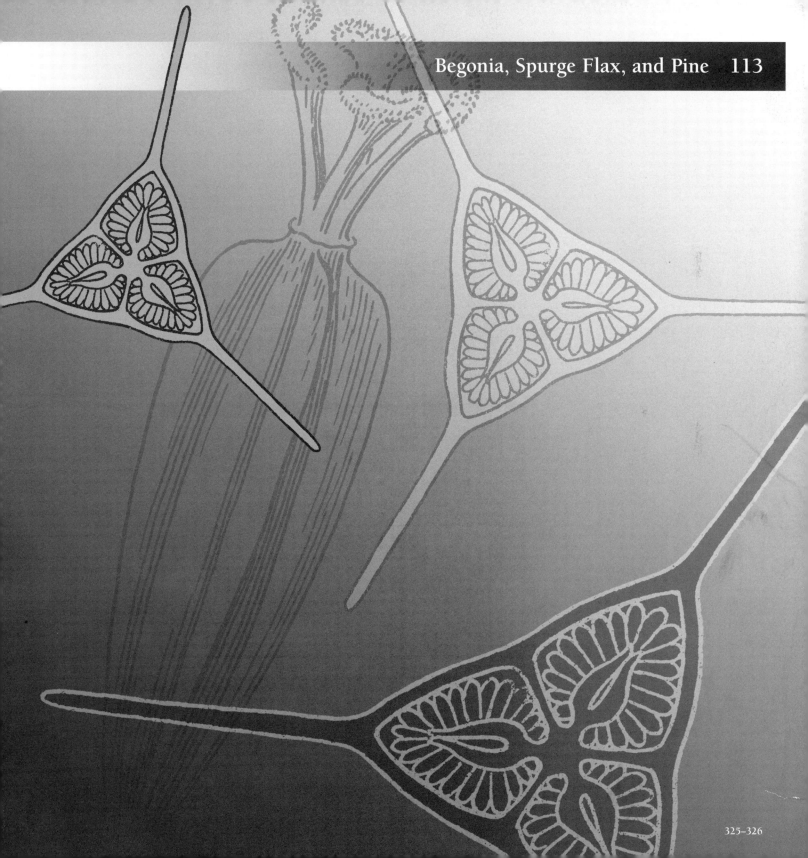

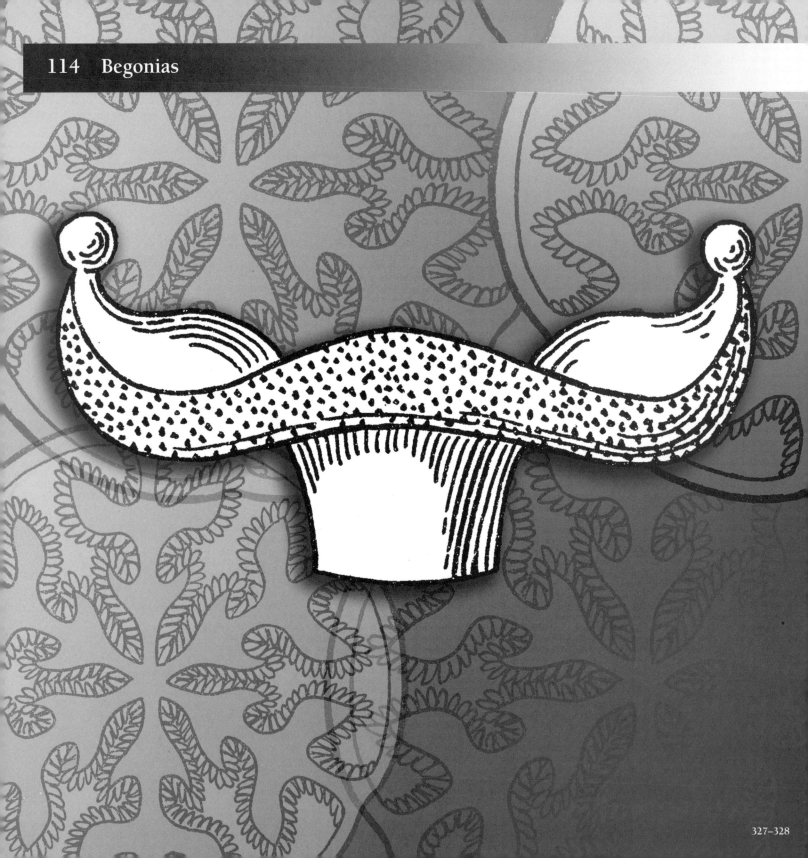

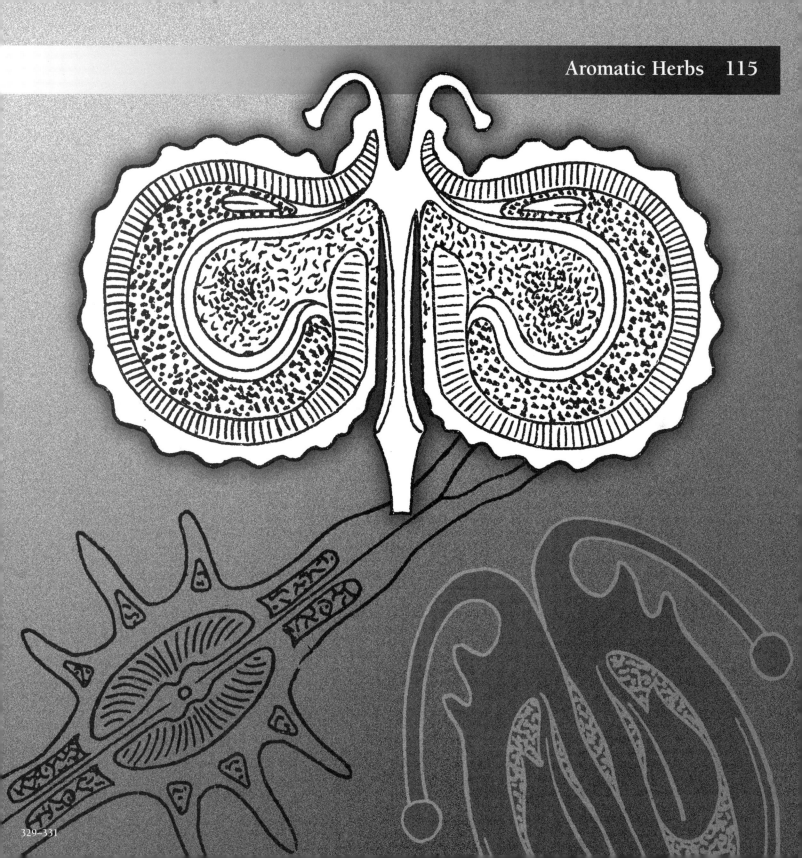

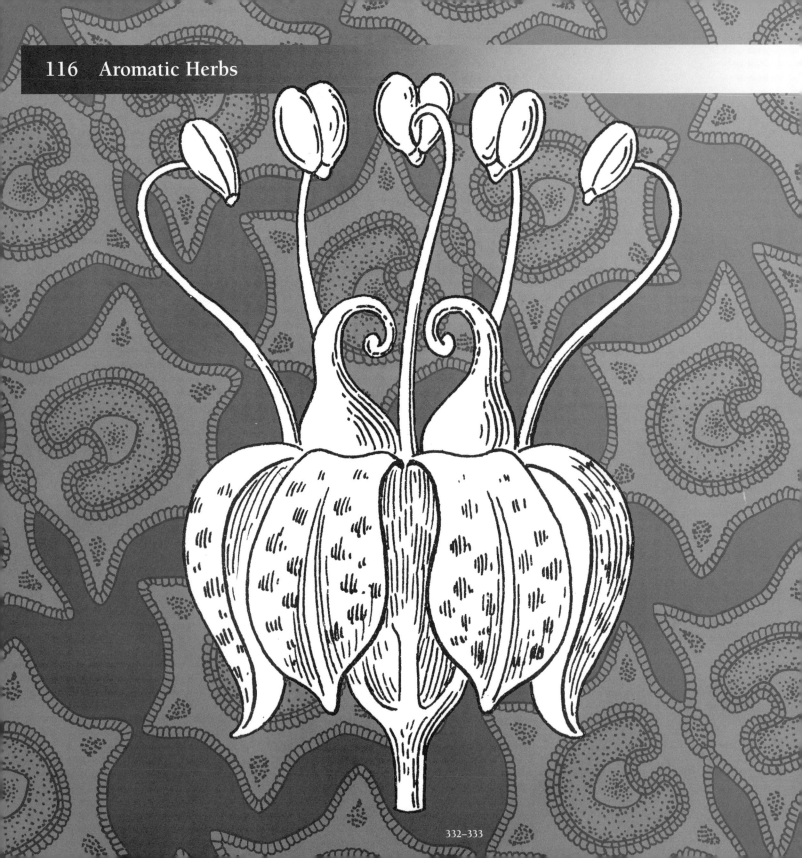

332–333

334–336

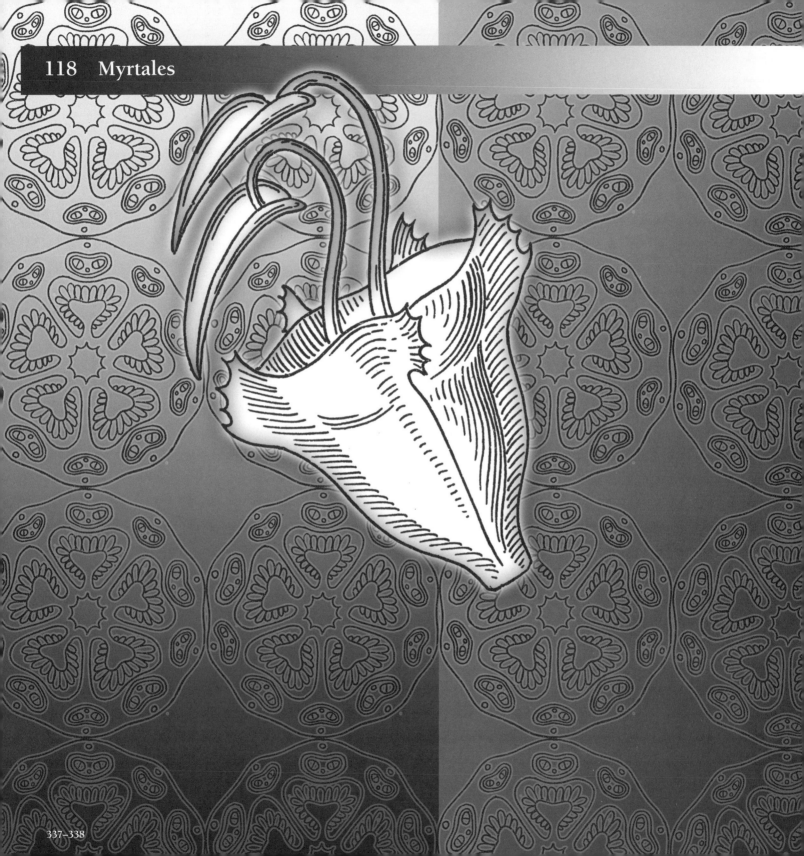

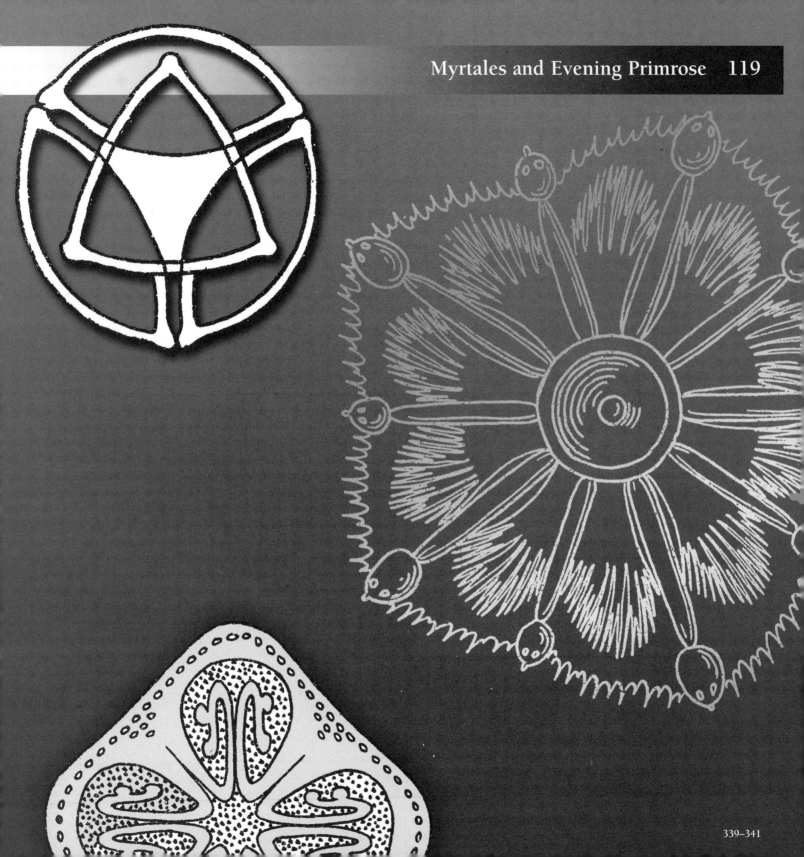

339–341

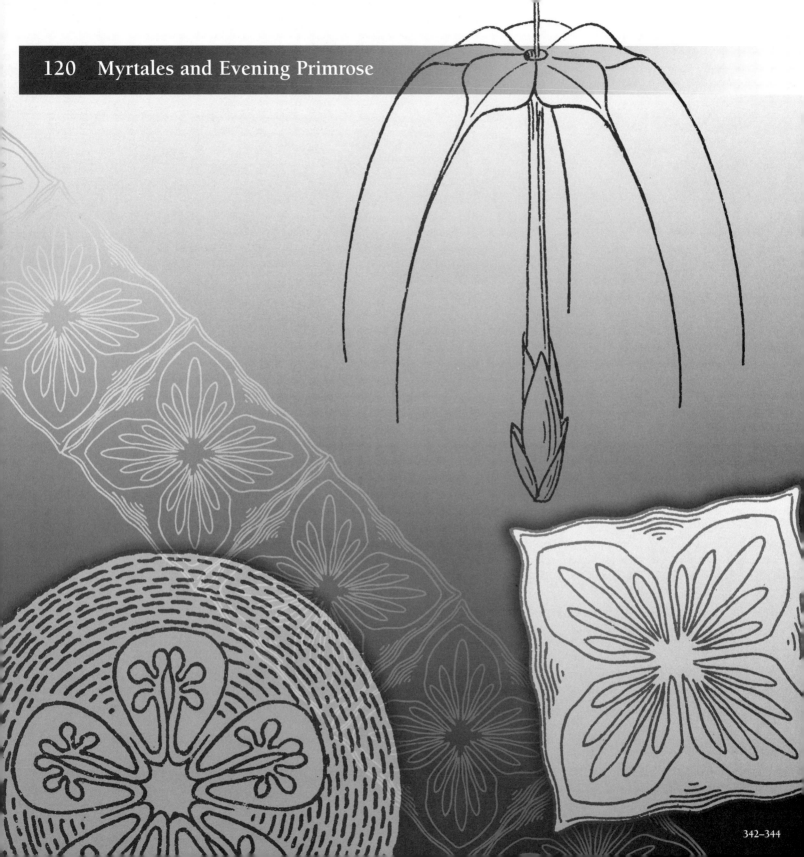

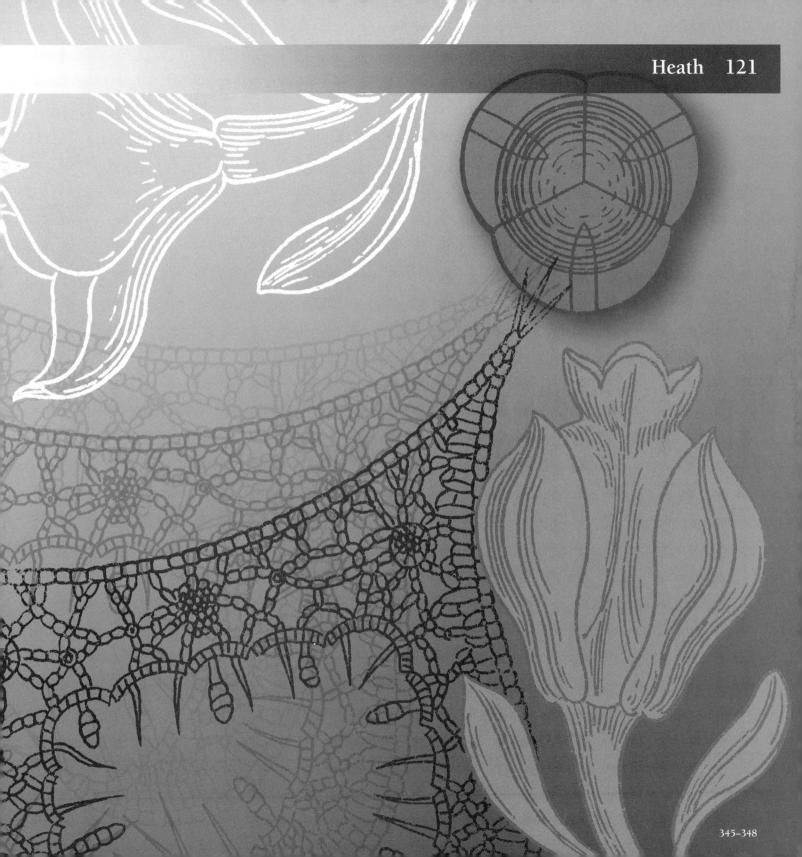

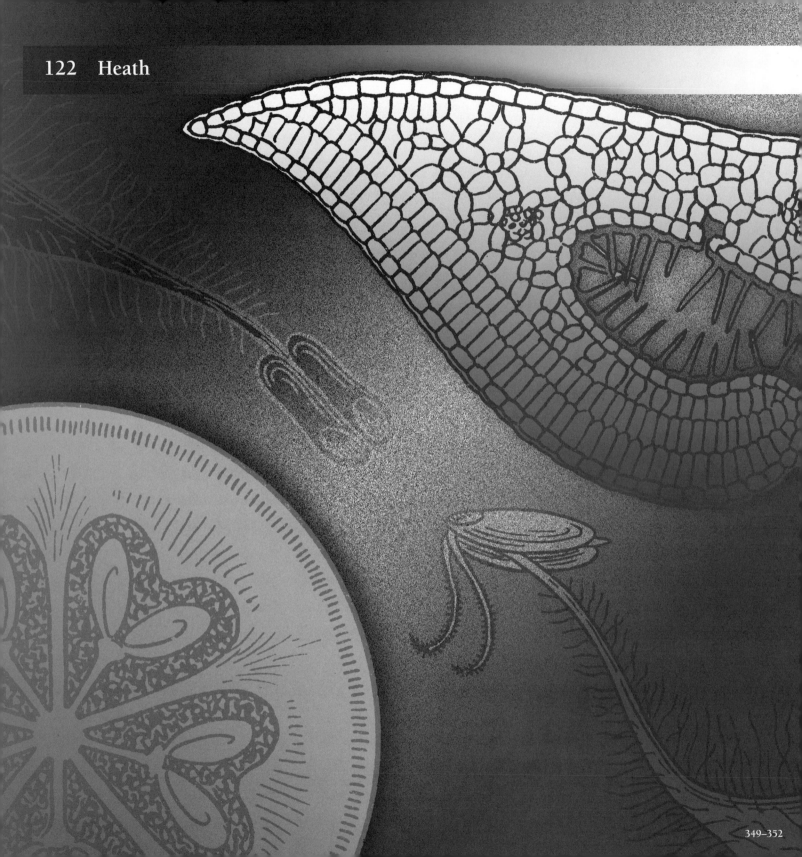

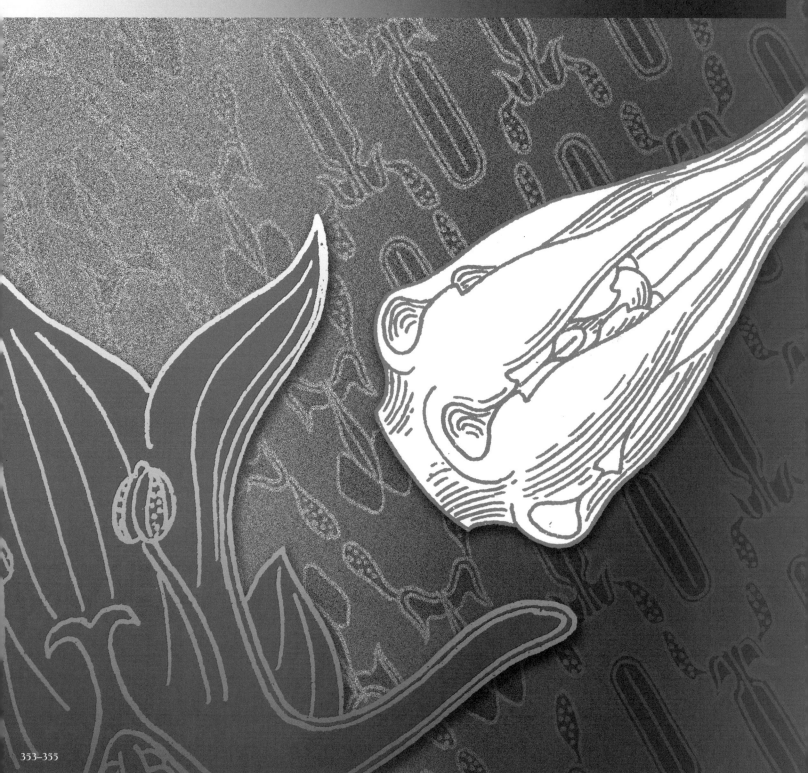

353–355

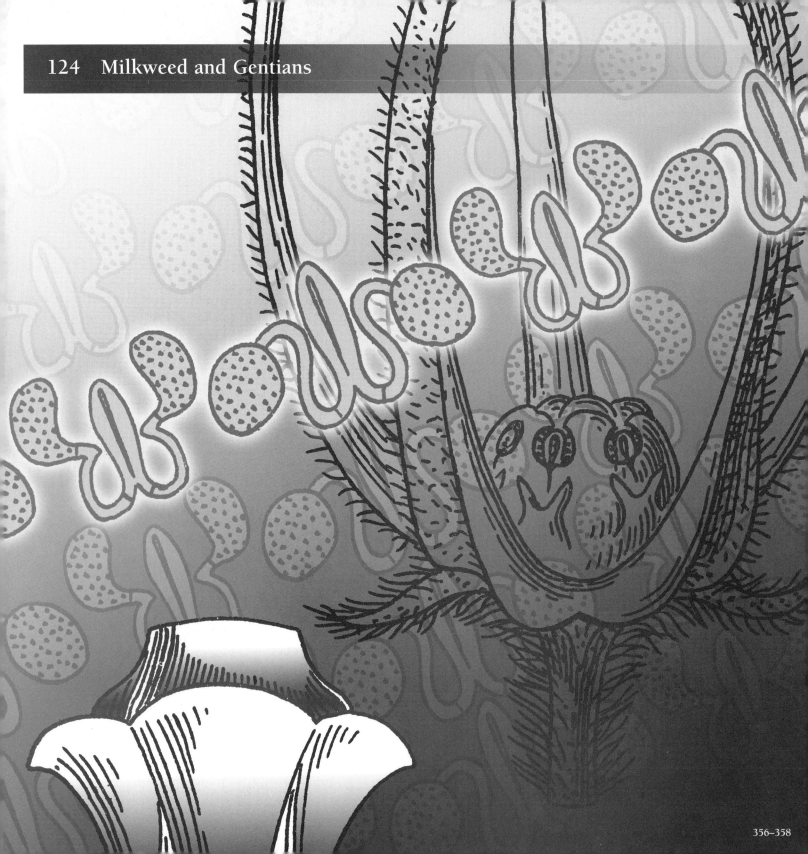

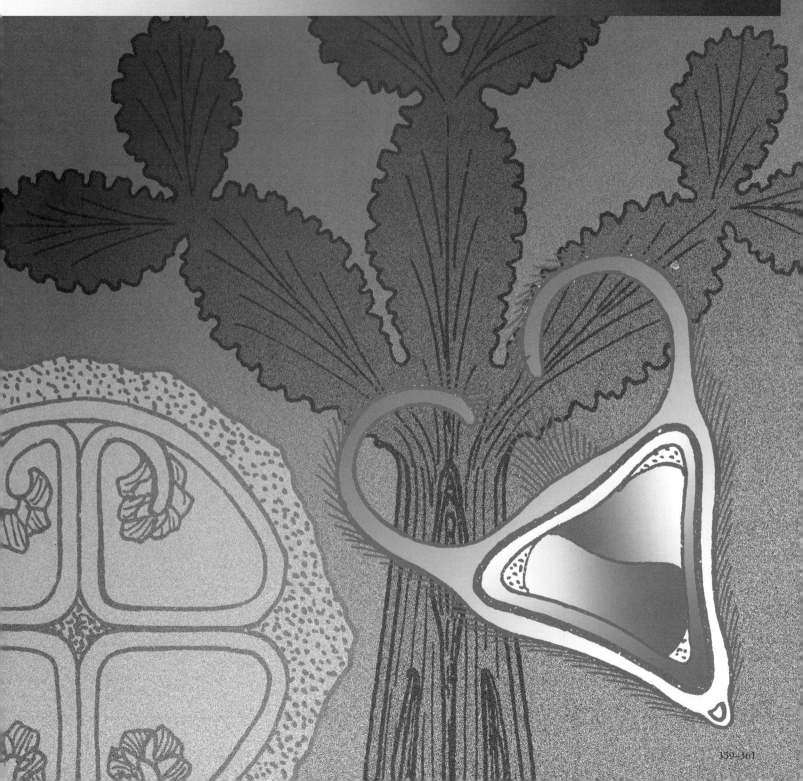

359–361

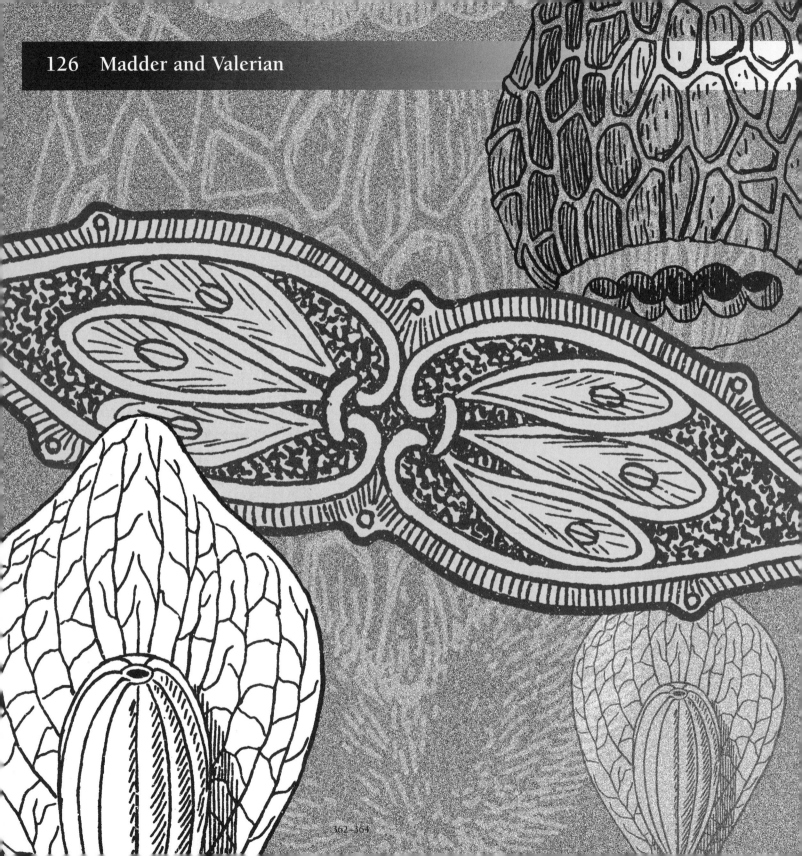

362–364